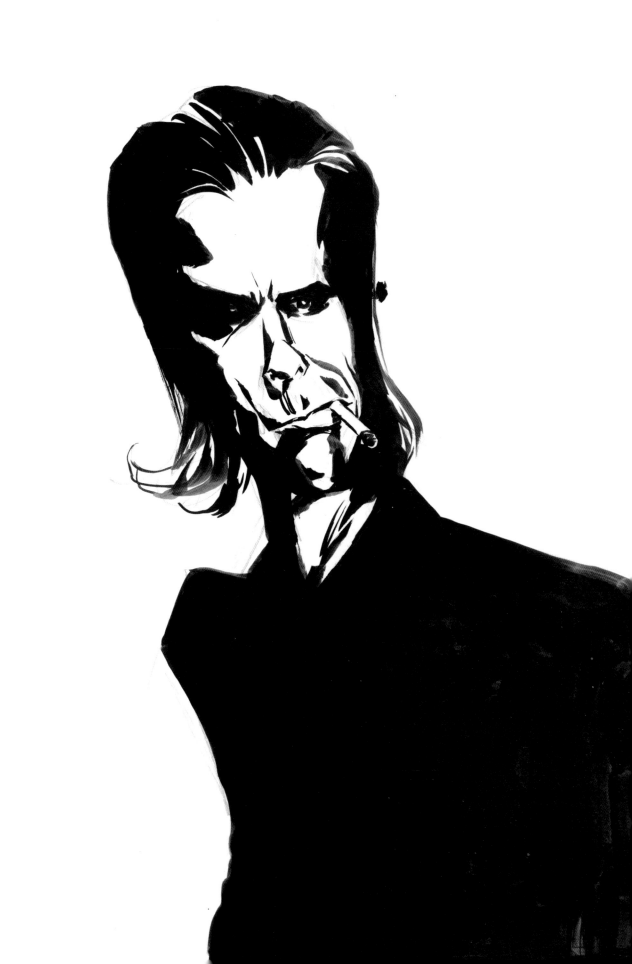

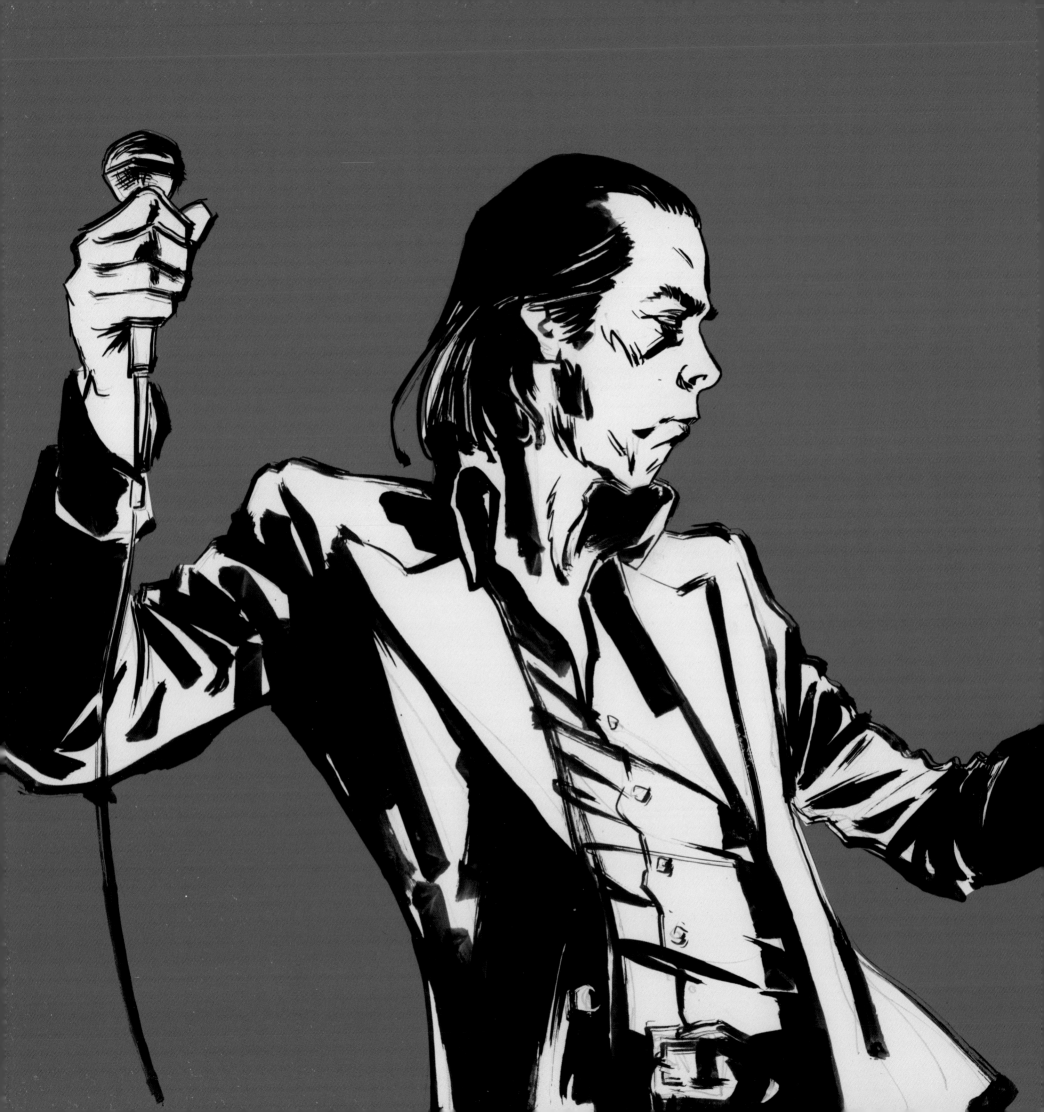

NICK CAVE
& THE BAD SEEDS

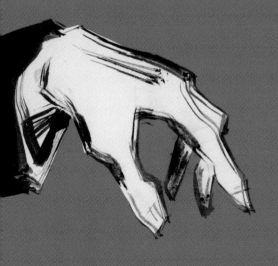

AN ART BOOK
REINHARD KLEIST

NICK CAVE: THE MIRROR SHARDS OF A SINGER

Every story has its beginning and end. It's simply a question of where, when and why it begins. Reinhard Kleist faced this problem while ruminating on the idea of a graphic novel about Nick Cave. Likewise, Nick Cave faces this problem with each song he intends to write.

My story with Nick Cave begins in an Italian restaurant, now demolished, close to the Docks concert venue on the Reeperbahn in Hamburg. Nick Cave's drummer, the Swiss native Thomas Wydler, had invited me to join him for dinner there after a Bad Seeds concert during the *Good Son* tour.

The Good Son was music that radically counterpointed the noise and aggressiveness of his previous albums, and was both sentimental and forgiving.

Nick Cave: "How did you like the show?"

Me: "It was great."

Nick Cave: "And?"

Me: "It was so different. Could it be that you're trying to reach everyone now? Even your fans' parents?"

Nick Cave, grumbling: "My mum always liked my music."

It is, after all, the job of the songwriter to keep spinning a story: from record to record, from concert to concert, from interview to interview.

Nick Cave was 33 at the time. I was 20. His show was sold out. Blixa Bargeld had fervently sung *The Weeping Song* in duet with Cave. And everyone in the audience had sensed a shift towards a tenderness previously considered impossible for Nick Cave and his Bad Seeds.

We met again occasionally over the following years, usually for interviews. Once, in the late nineties, I asked him how he prepared himself afresh for each upcoming concert. His answer was remarkably illuminating: in order to freely move around on stage, he would imprint in his mind the city plans, landscapes and other scenes he had created and imagine himself within them.

When Nick Cave sings a song such as *Red Right Hand*, with its first line, "Take a little walk to the edge of town / And go across the tracks / Where the viaduct looms / Like a bird of doom", he is moving through this described scenario at the edge of a city with its train tracks.

In 2000, I wrote what was at that point the only comprehensive biography on the singer. So before Reinhard Kleist began work on the graphic novel *Nick Cave: Mercy on Me*, we met in a café in Berlin. We spoke about the non-linearity of Cave's compositions.

For, as concrete as many of Nick Cave's songs may be, they also dissipate into an all-encompassing musical and lyrical universe. Cave's debut novel *And the Ass Saw the Angel* from 1993 must also be mentioned in this context. In this angry tale, written under the influence of heroin, Cave tells of a squalid stretch of land, the settings of which can be found as trace elements in a range of later songs.

However, in neither his songs nor his debut novel is it enough for Nick Cave to tell a narrative from a single perspective. The novel's introductory scene is described through the eyes of a crow rising up into the sky and looking back down on the land. Such an extreme bird's-eye view is familiar from films, such as Alfred Hitchcock's *The Birds*. Cave's view of his characters and locations is both holistic and fragmentary. On the one hand, he embeds the heroes and anti-heroes of his songs in landscapes and places fully fleshed out by the singer beforehand – something unique in pop music. On the other hand, Cave also zooms in on the key biographical moments of his protagonists.

The best example of this is *The Mercy Seat*. Here, Nick Cave sings from the perspective of the last inner monologue of a murderer on death row, who is attempting to convince the listener in increasingly dramatic tones that he is innocent of the crime. Only in the last verse does he admit, "And anyway I told the truth / But I'm afraid I told a lie."

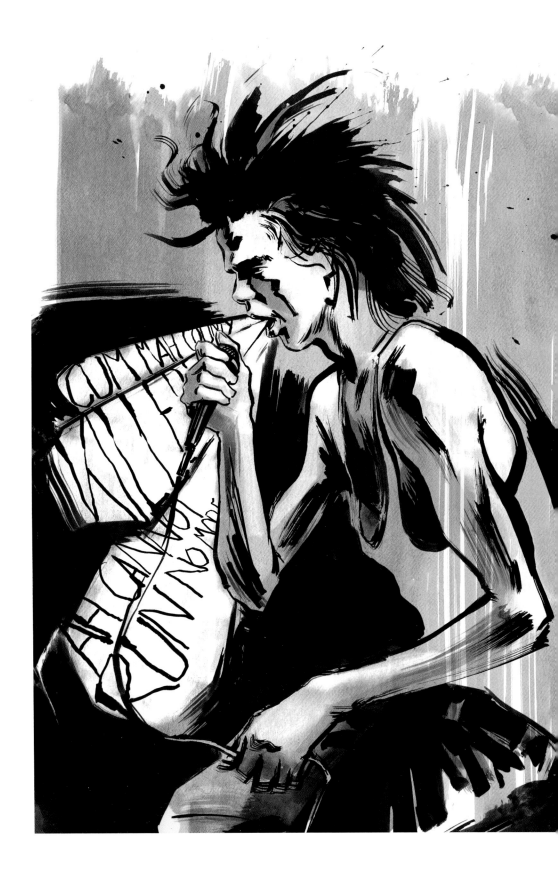

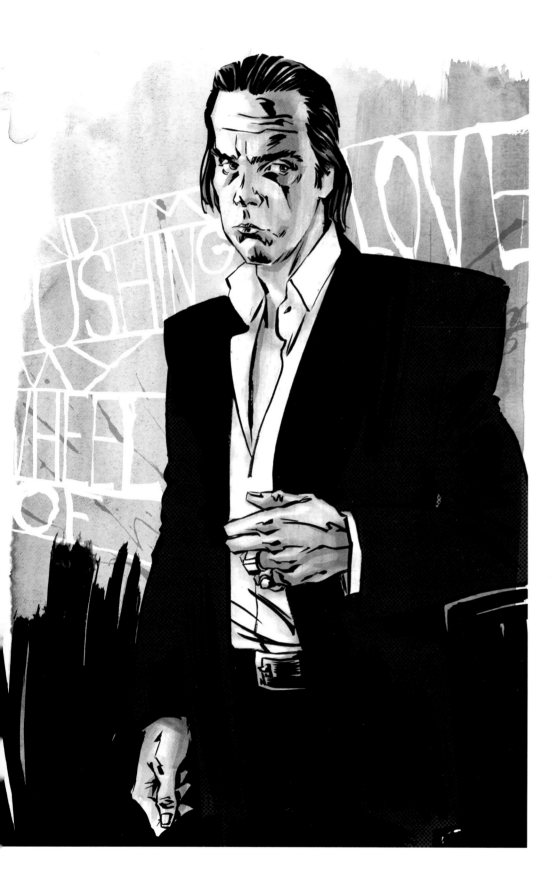

Nick Cave's talent for seeing the world as a novelist or film director initially presented Reinhard Kleist with a difficult task. A first draft of the graphic novel telling Cave's biography in a chronological fashion from beginning to present day proved oversimplified and a dead end. It required a second approach to tell the story asymmetrically, as one long associative episode of flashbacks, dream visions and illustrated retellings of specific songs. And suddenly everything fell into place, despite the narrative technique of Kleist's finished work becoming even more sophisticated through the addition of temporal shifts. But like Nick Cave's storytelling technique in his own songs, Kleist's approach offers new discoveries and details with each read.

In turn, this art book brings together dozens of drawings, including many in colour, which arose as Reinhard Kleist closed in on his subject. They are character and anatomy studies, as well as parallel and alternative narrations. Anyone who knows Kleist knows just how astonishingly quickly he can draw. He happily draws live during readings, allowing the confident strokes of his nascent drawings to be filmed and projected onto a screen. Over two years, Kleist drew countless fantastic drawings on the subject of Nick Cave, quickly threatening to burst the bindings of the graphic novel. Many of these have now been saved in this art book. Kleist has also illustrated the stories for the three Cave songs *Deanna*, *The Good Son* and *Stagger Lee* for this book.

However, this collection of moments from Nick Cave's life is, above all, a tour de force through the many different facets of his personality and the recurring themes of his songs. Each drawing is like a shard of mirror, a piece of the puzzle, a part of the kaleidoscope.

Equally fascinating about Reinhard Kleist's close-ups from the life of the singer is that he has managed to flesh out the fraudulence, the playfulness and the purportiveness in his biography.

From the beginning, Nick Cave has managed to make his career a story to be told, a legend. When Cave lived with Christoph Dreher, the leader and bassist of the band Die Haut, near Kottbusser Tor in West Berlin in the eighties, he created himself as a superstar of the underground, which he actually only became through this claim. The places Nick Cave hung out at resembled film sets. His tiny room in the shared apartment: a sanctuary and writing room covered with manic scribbling. His sitting room: the Risiko bar next to the Yorckstraße S-Bahn bridges, where Cave turned the nights into days with Blixa Bargeld. His work room: the Hansa recording studio in Köthener Straße, right alongside the Berlin Wall and where David Bowie and Iggy Pop had recorded.

His friends and acquaintances all agree on one thing, that wherever you encountered Cave, the hierarchy was thus: here, the star Nick Cave; there, the public. The singer required no stage – just the presence of third parties was sufficient to make the staging perfect.

Anyone with such an aura need not worry about his legend. On top of that, conversations with Nick Cave always follow the same pattern, and yet they are never alike. You never know quite when Cave is talking from personal experience and where the fiction begins. Both are convincing. Reinhard Kleist used this conflict to formulate a poetic licence that allowed him to insert free associations in among the truths and claims that Cave has made public through biographies, interviews, films and TV documentaries, and naturally also through his songs, poems and novels.

Nick Cave is a great cineaste. He has composed many film scores and even appeared in several films, including Wim Wenders' *Der Himmel über Berlin* and John Hillcoat's *Ghosts... of the Civil Dead*. His favourite films include Terrence Malick's *Badlands* and D.A. Pennebaker's Bob Dylan film *Don't Look Back*. Both are about outsiders becoming stars. The first ends up in the electric chair after a trigger-happy odyssey through Dakota. The second imagines and manifests his future fame. Nick Cave has learned from both.

Another of Cave's favourite films is the John Ford western *The Man Who Shot Liberty Valance*, which ends with the now famous words: "When the legend becomes fact, print the legend." The same can be said about Nick Cave as about Reinhard Kleist's approach to the fictional character of Cave.

From occasionally contradictory sources and the singer's own statements, Kleist has woven a legend that, through the credible assertion of its own claim, all of a sudden becomes fact.

In doing this, Reinhard Kleist answers the question about the beginning and end of his graphic novel about Cave with this art book: every path leads to a further facet, and each step Nick Cave takes is a small step for the singer but a great leap for pop culture.

Max Dax (born 1969) is a publicist, journalist and photographer. From 2007 to 2010, he was editor in chief of the cultural magazine *Spex*. In 2000, together with Johannes Beck, he released the first comprehensive biography of Nick Cave, titled *The Life and Music of Nick Cave: An Illustrated Biography* (published by Die Gestalten). Max Dax lives in Berlin, where he runs the Santa Lucia gallery.

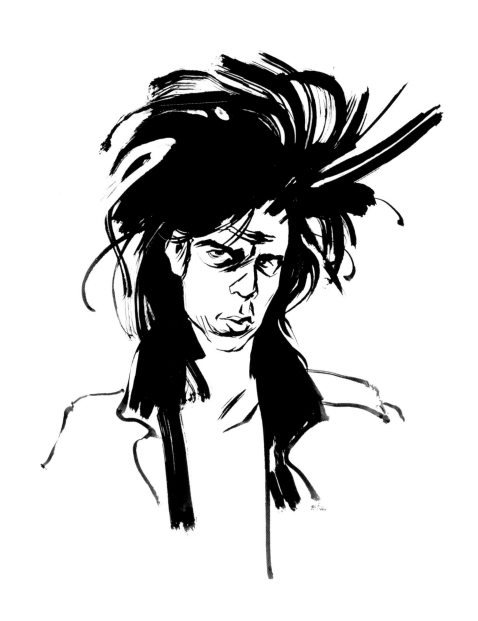

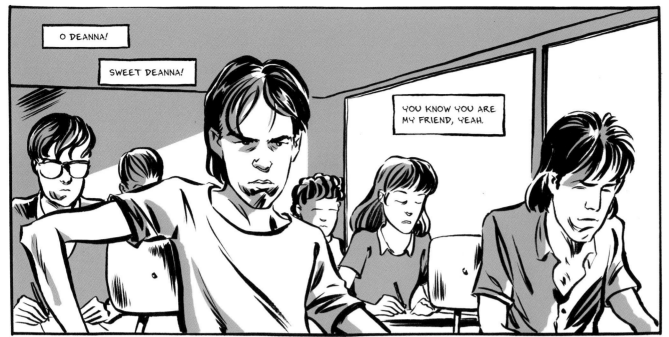

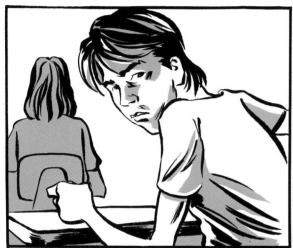

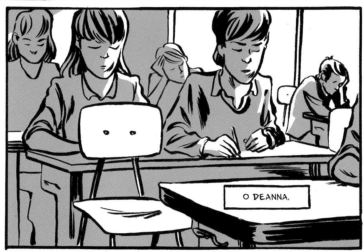

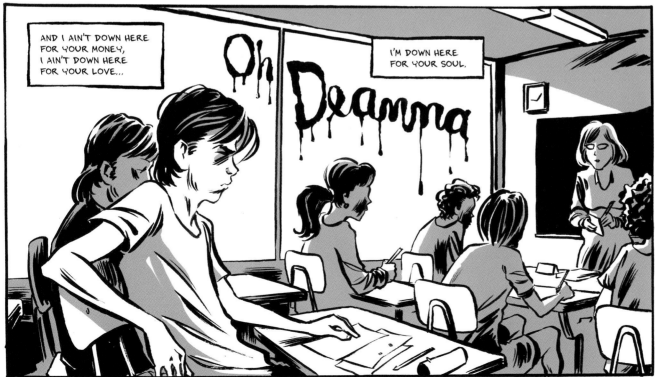

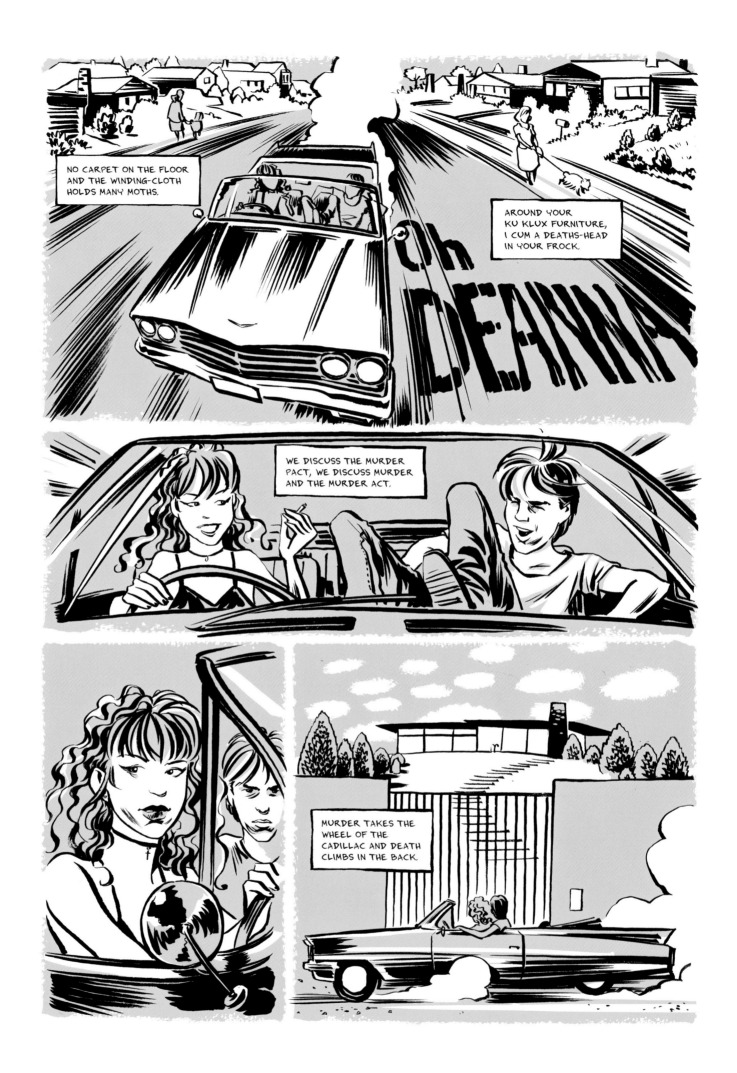

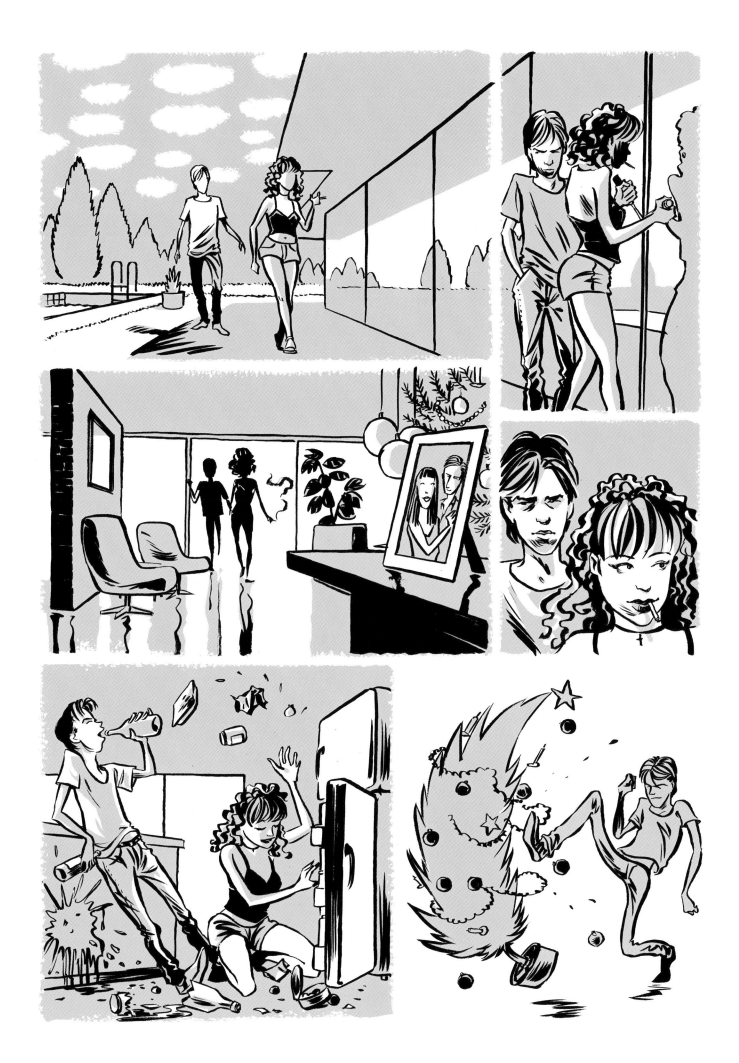

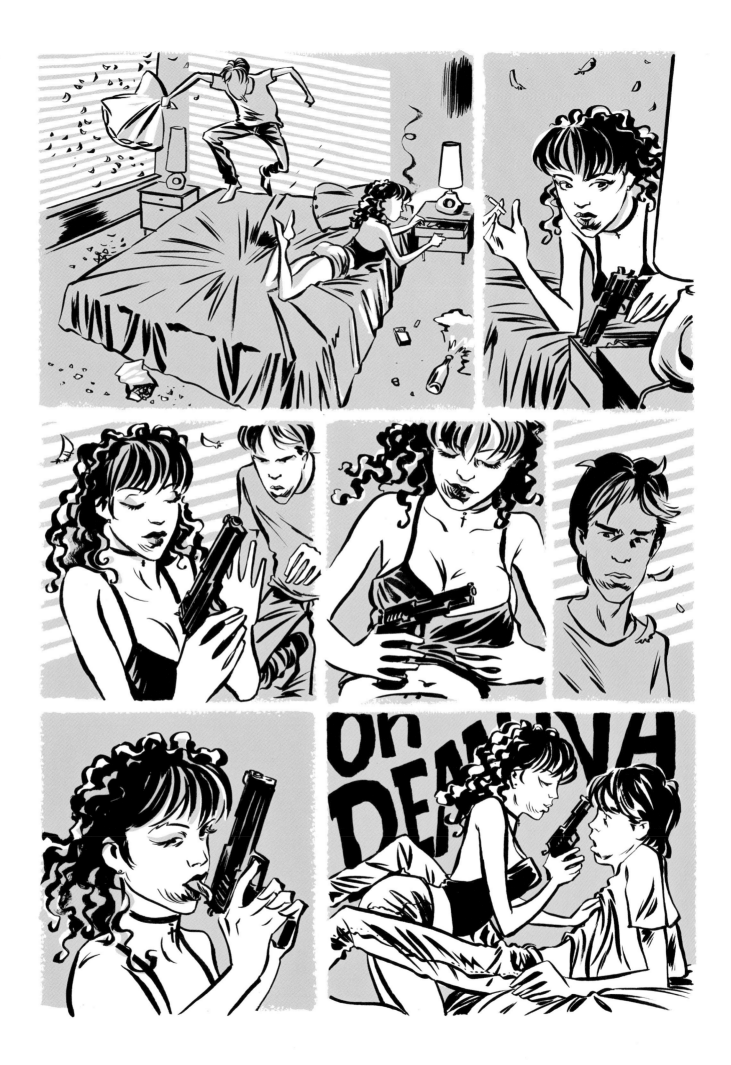

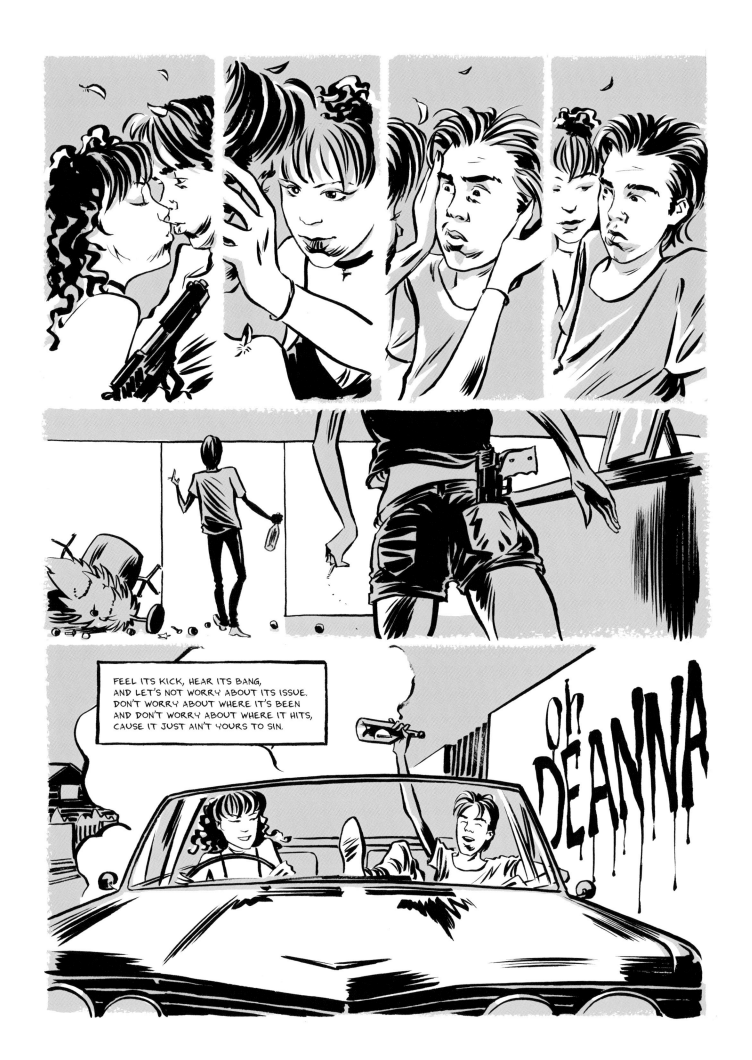

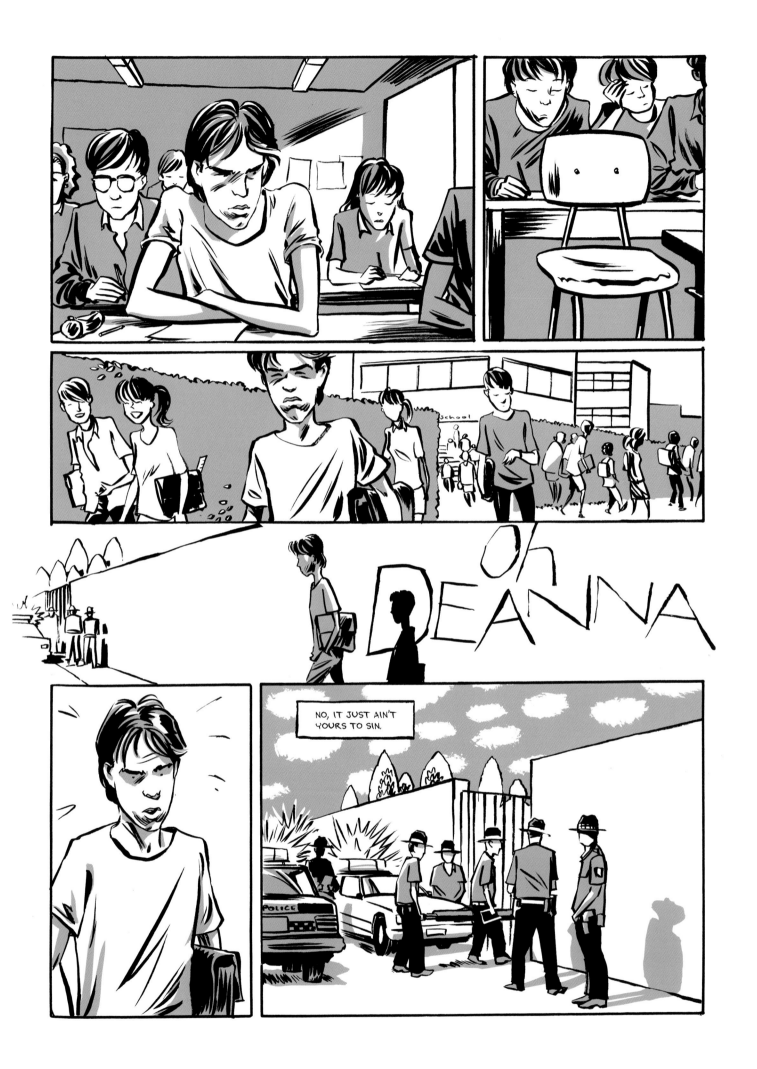

OH DEANNA

NO, IT JUST AIN'T YOURS TO SIN.

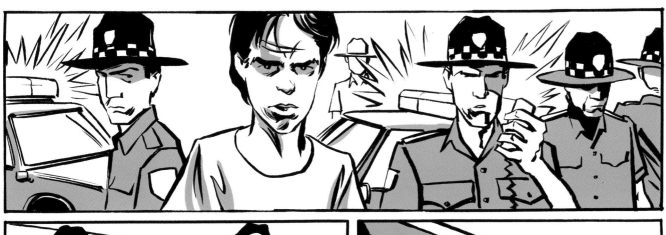

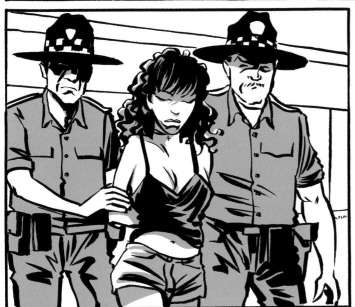

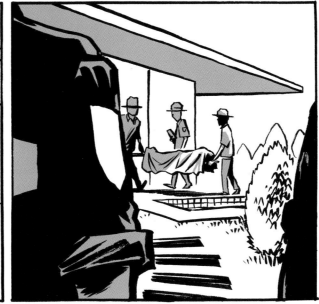

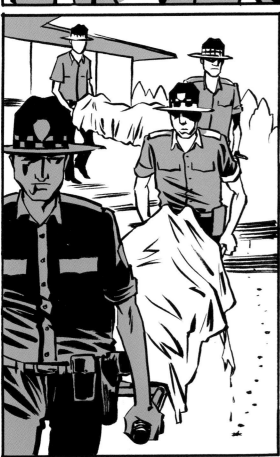

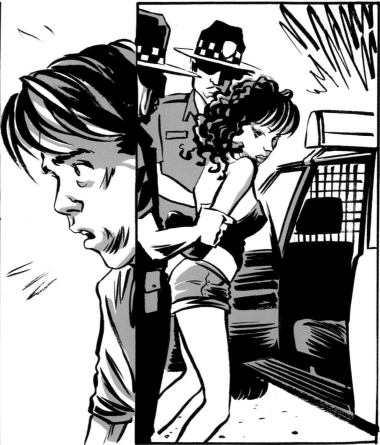

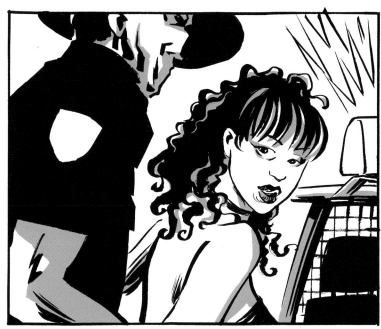

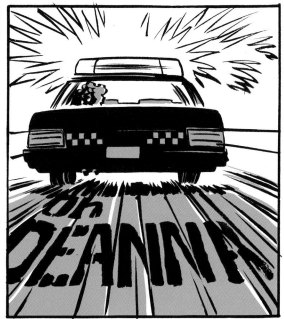

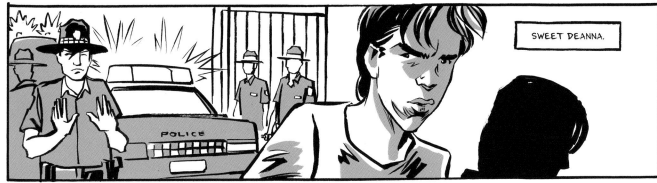

SWEET DEANNA.

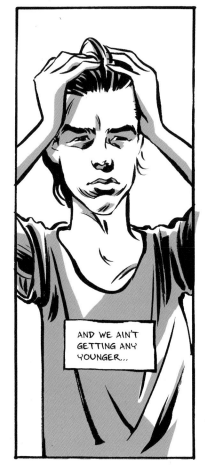

AND WE AIN'T GETTING ANY YOUNGER...

AND I DON'T INTEND GETTIN' ANY OLDER.

THE SUN A HUMP AT MY SHOULDER.

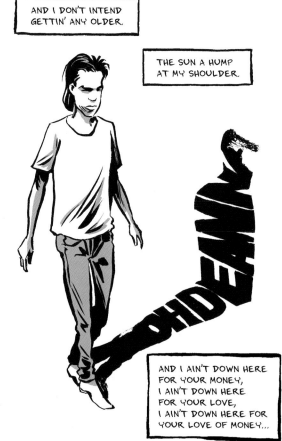

AND I AIN'T DOWN HERE FOR YOUR MONEY, I AIN'T DOWN HERE FOR YOUR LOVE, I AIN'T DOWN HERE FOR YOUR LOVE OF MONEY...

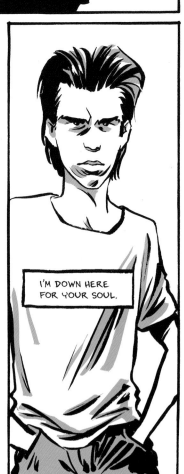

I'M DOWN HERE FOR YOUR SOUL.

PLEASURE HEADS MUST BURN – THE BIRTHDAY PARTY

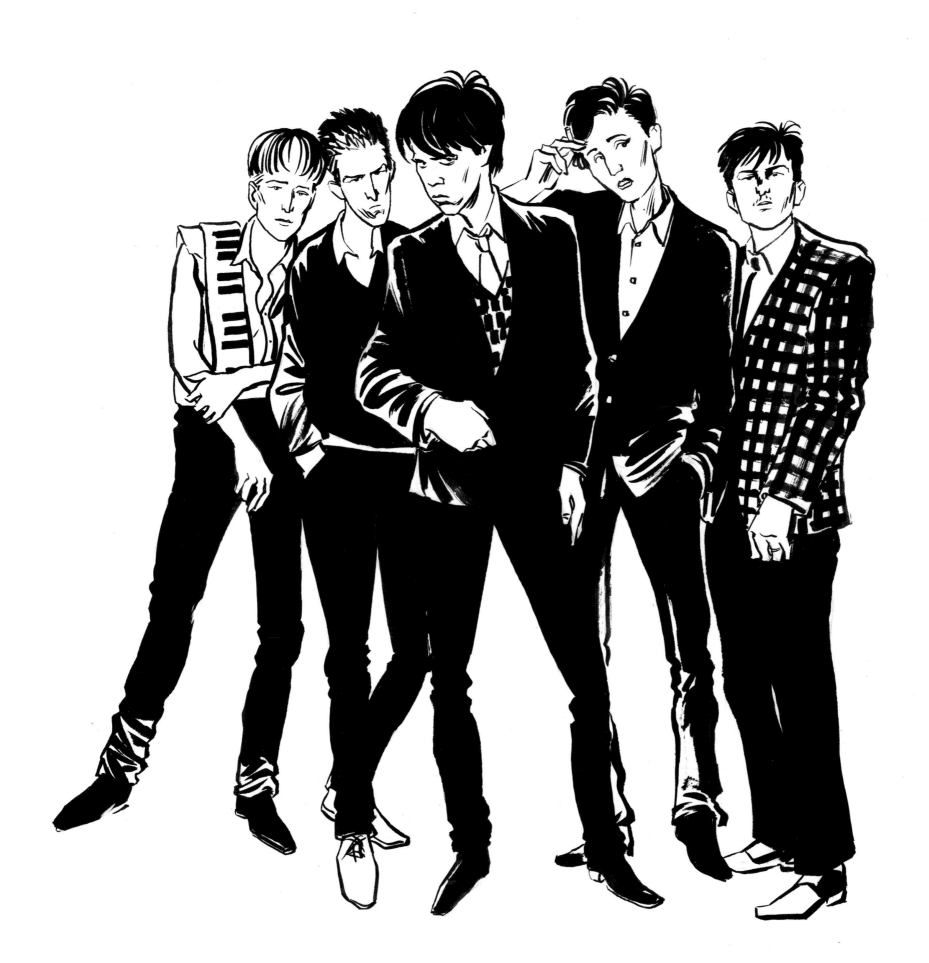

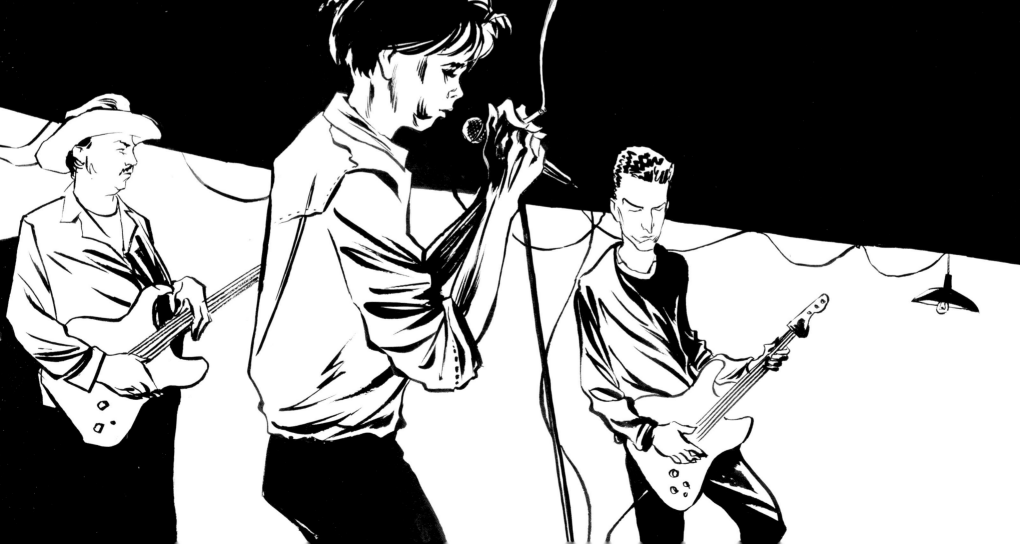

◀ The Boys Next Door, Nick Cave's first band in Australia, circa 1978.

From left: Phill Calvert, Mick Harvey, Nick Cave, Rowland S. Howard, Tracy Pew.

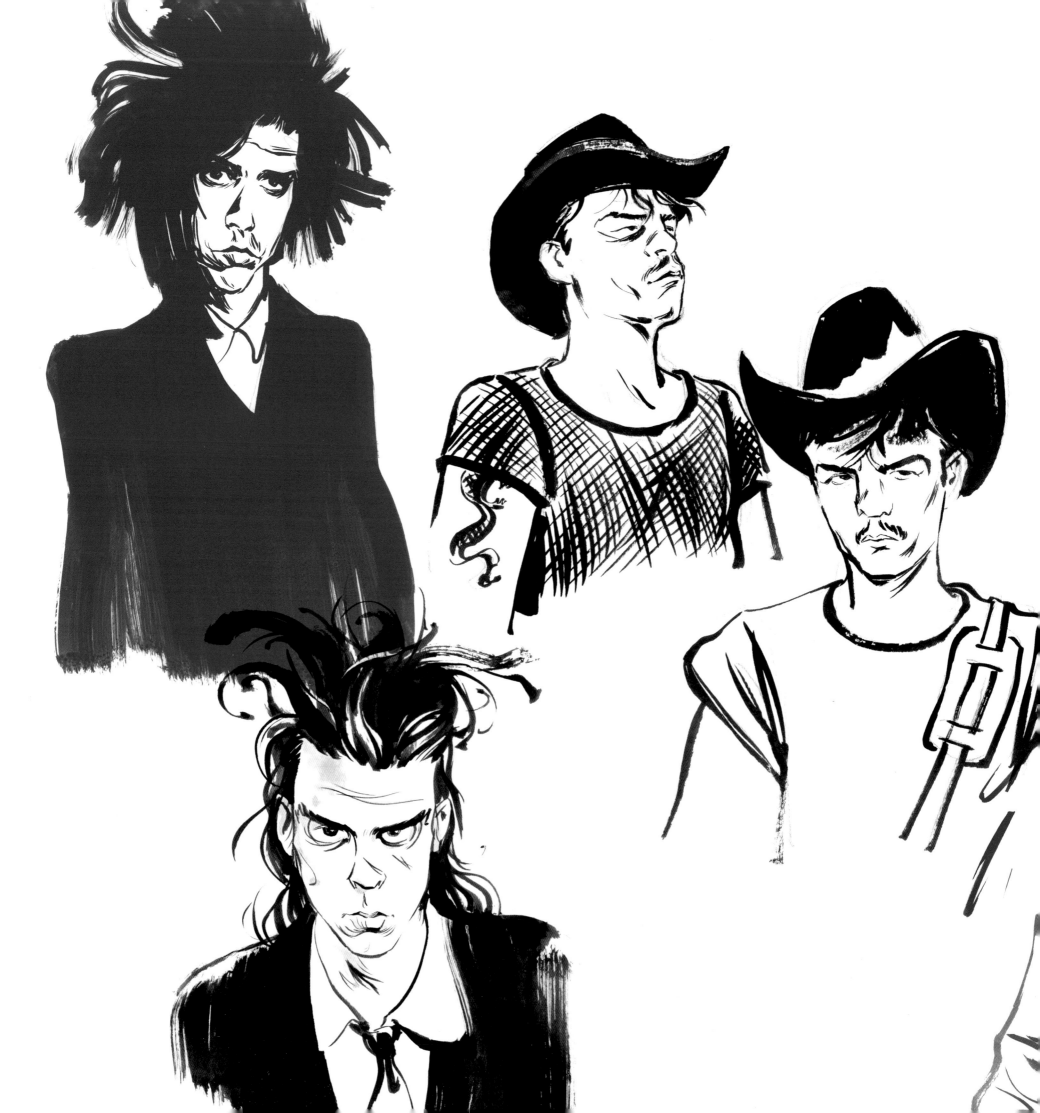

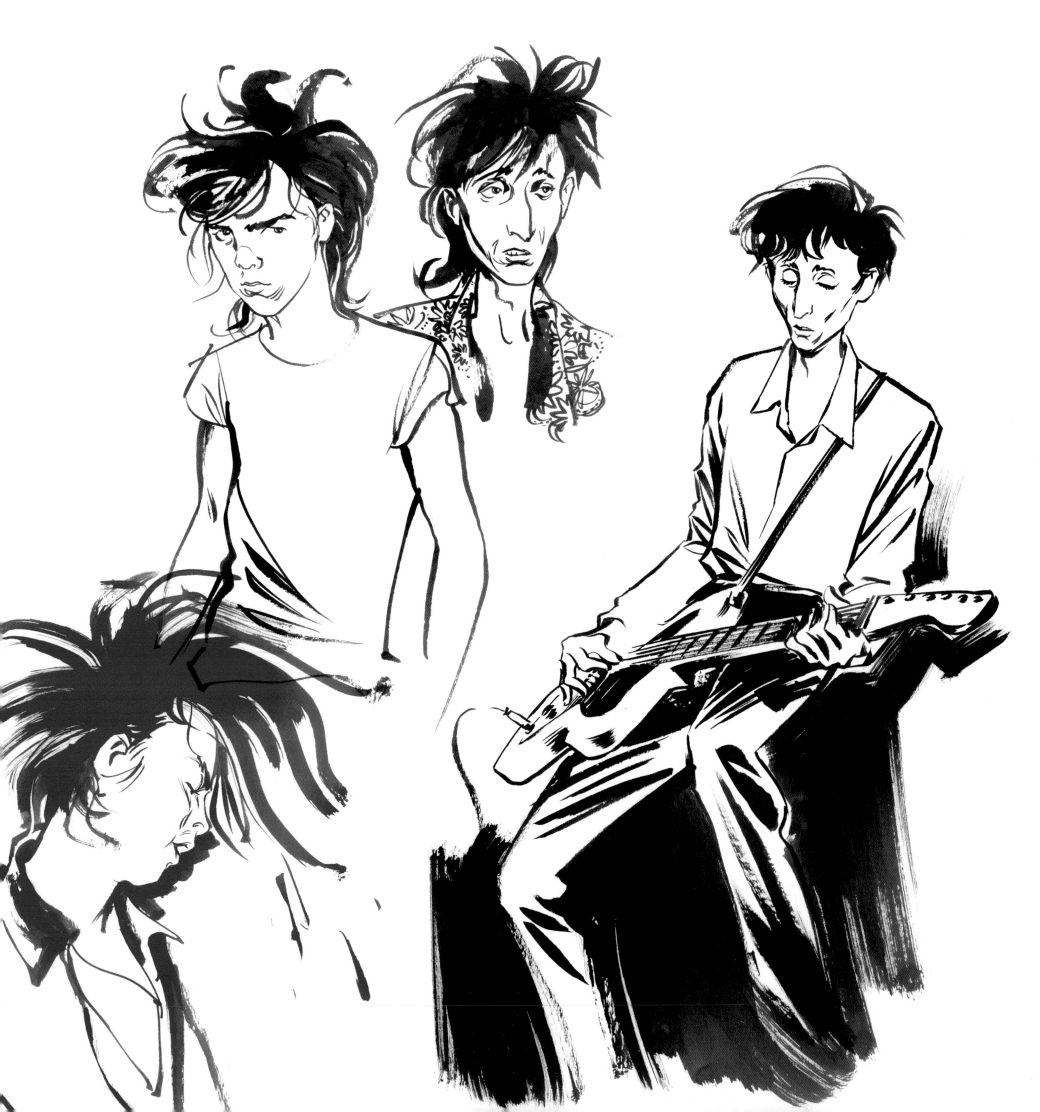

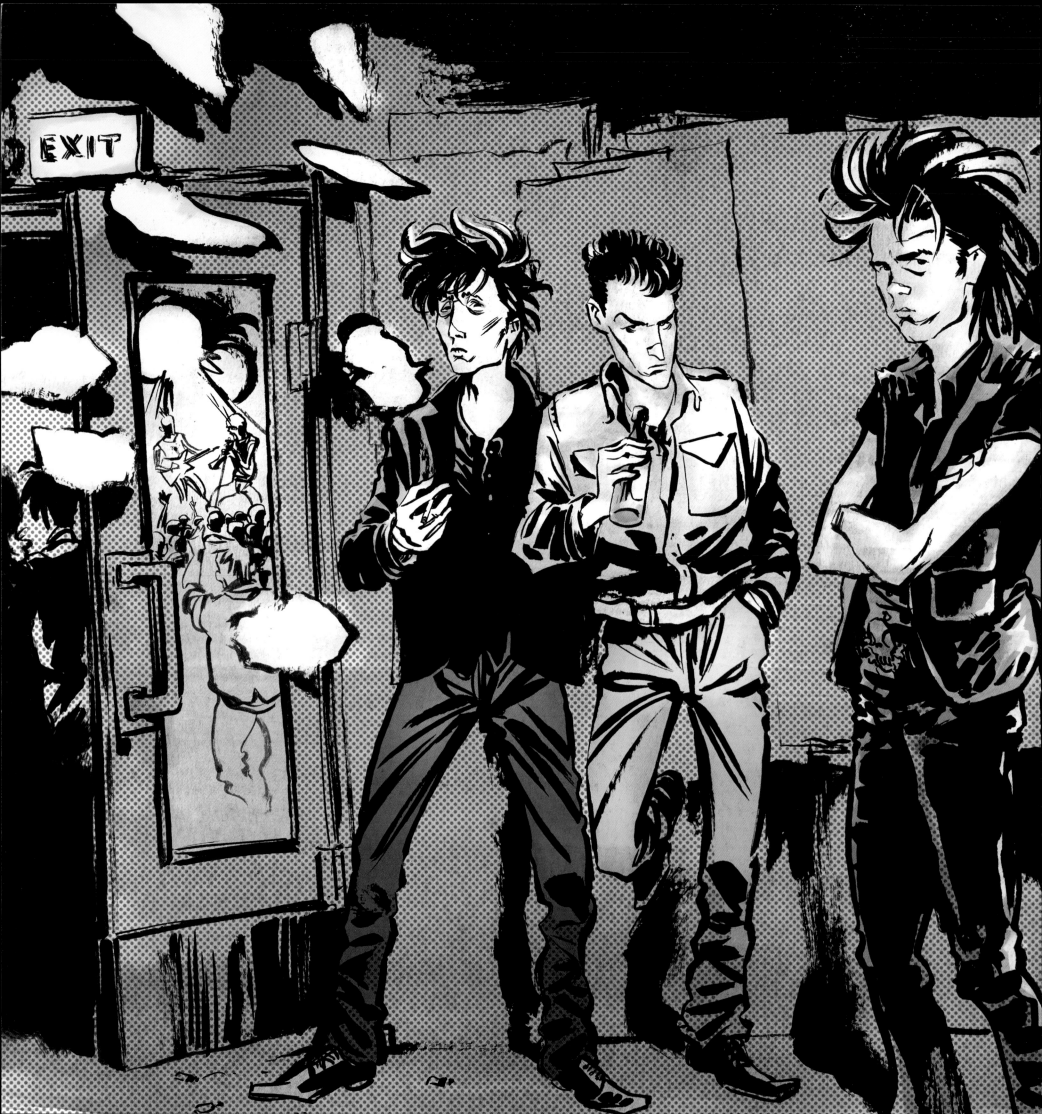

Sceptical: The Birthday Party in the early eighties in London.

From left: Rowland S. Howard, Mick Harvey, Nick Cave, Tracey Pew.

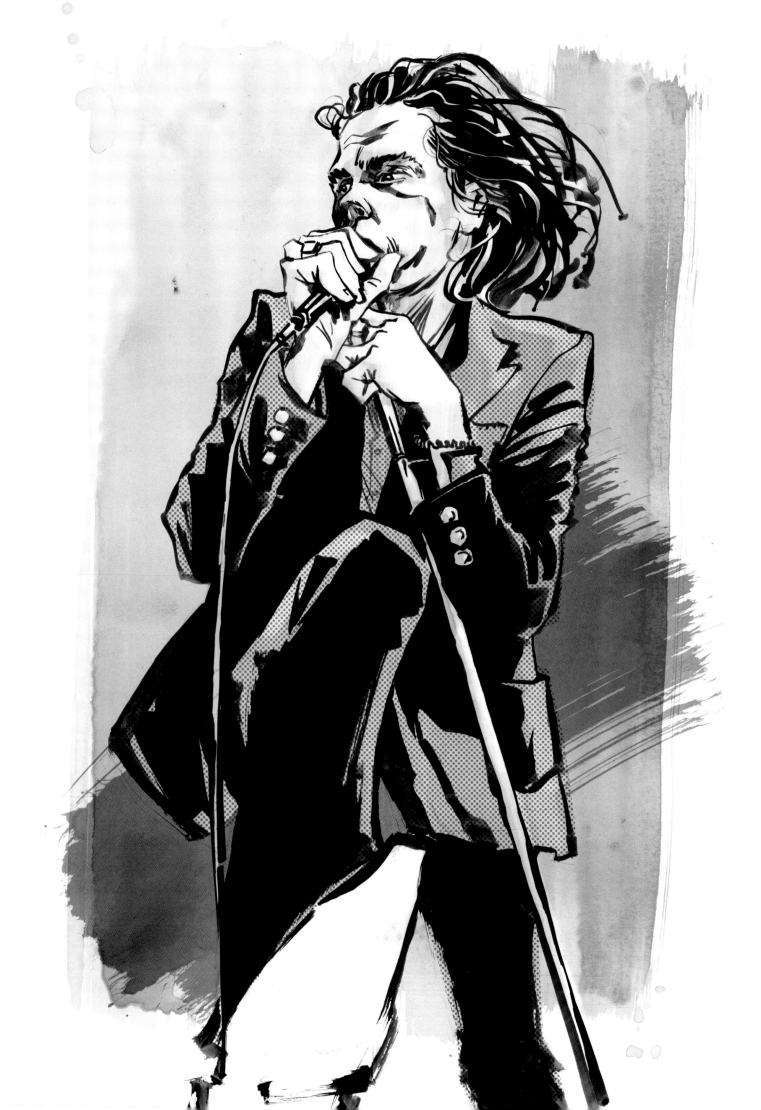

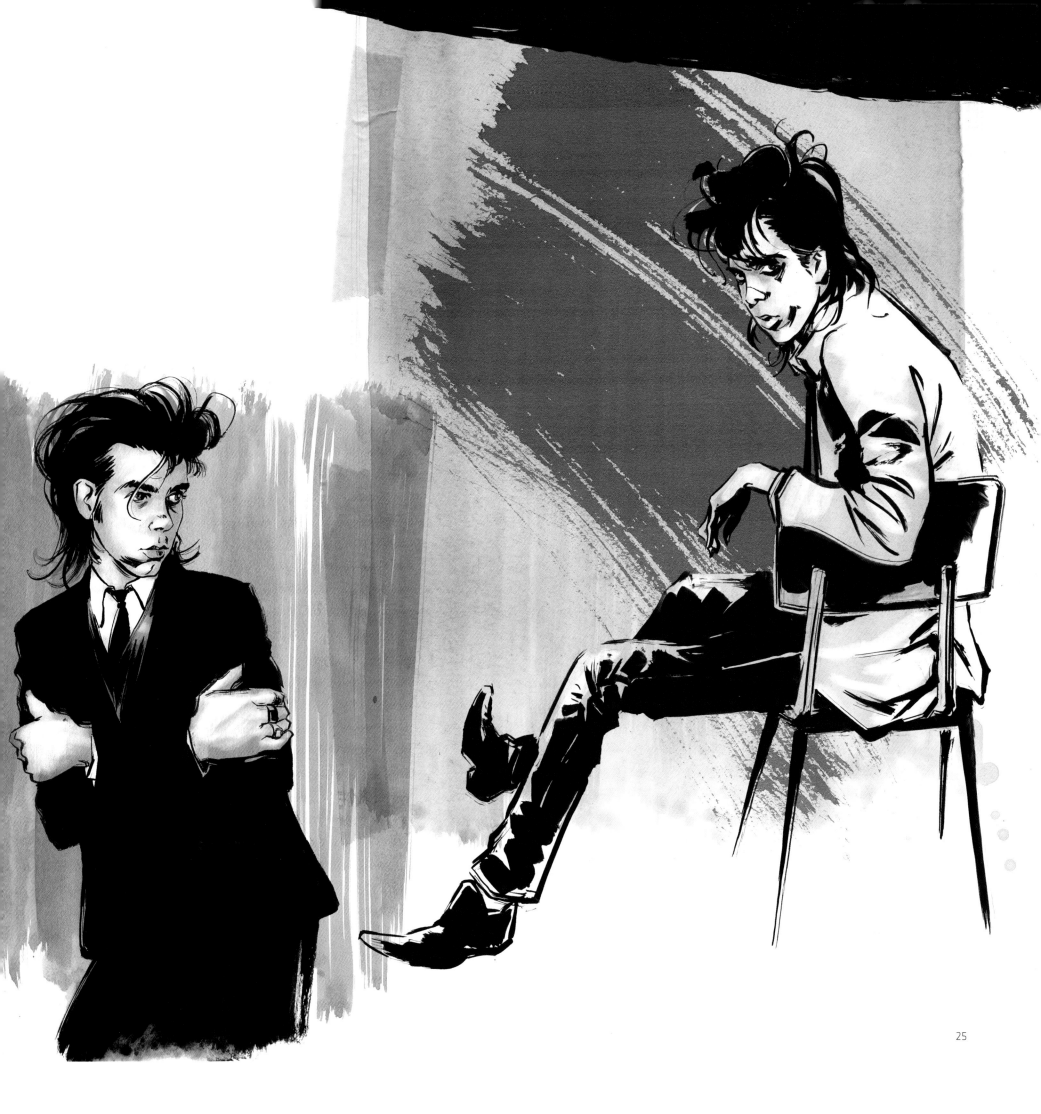

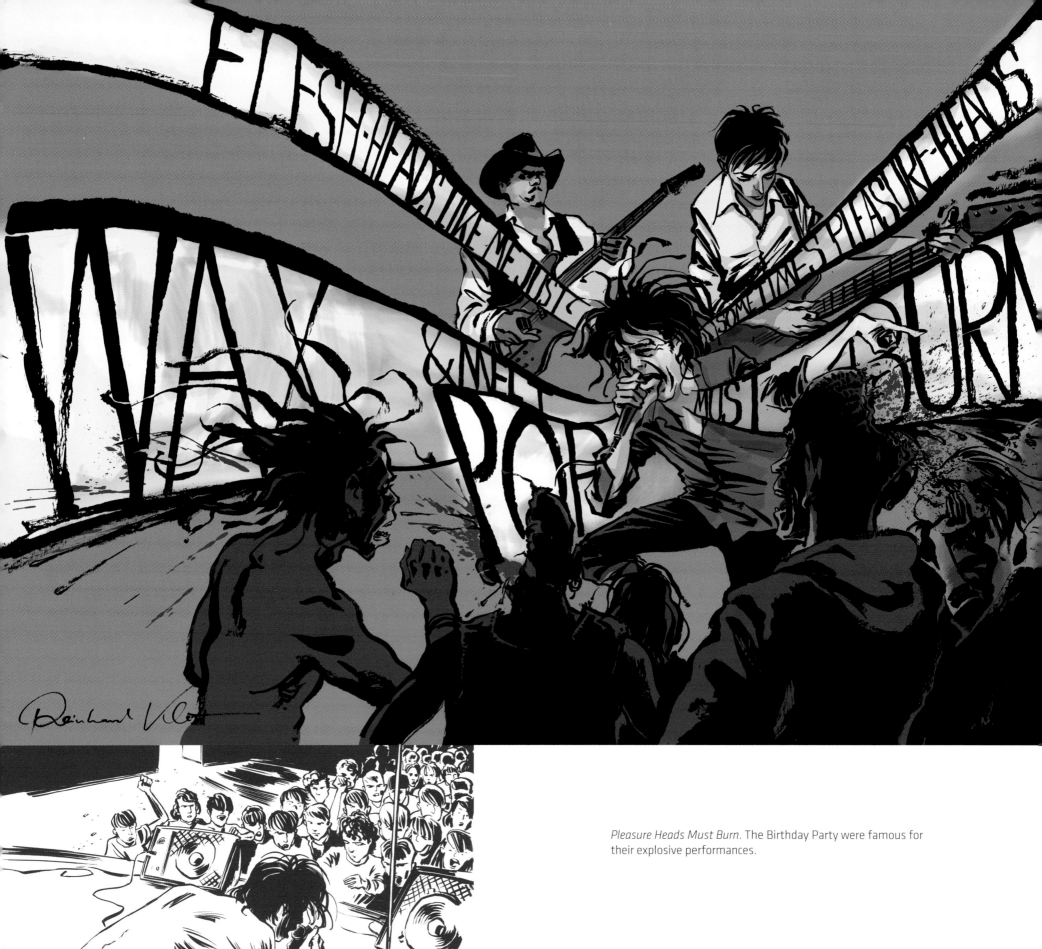

Pleasure Heads Must Burn. The Birthday Party were famous for their explosive performances.

Tracy Pew, Nick Cave, Rowland S. Howard and Mick Harvey backstage. ▶

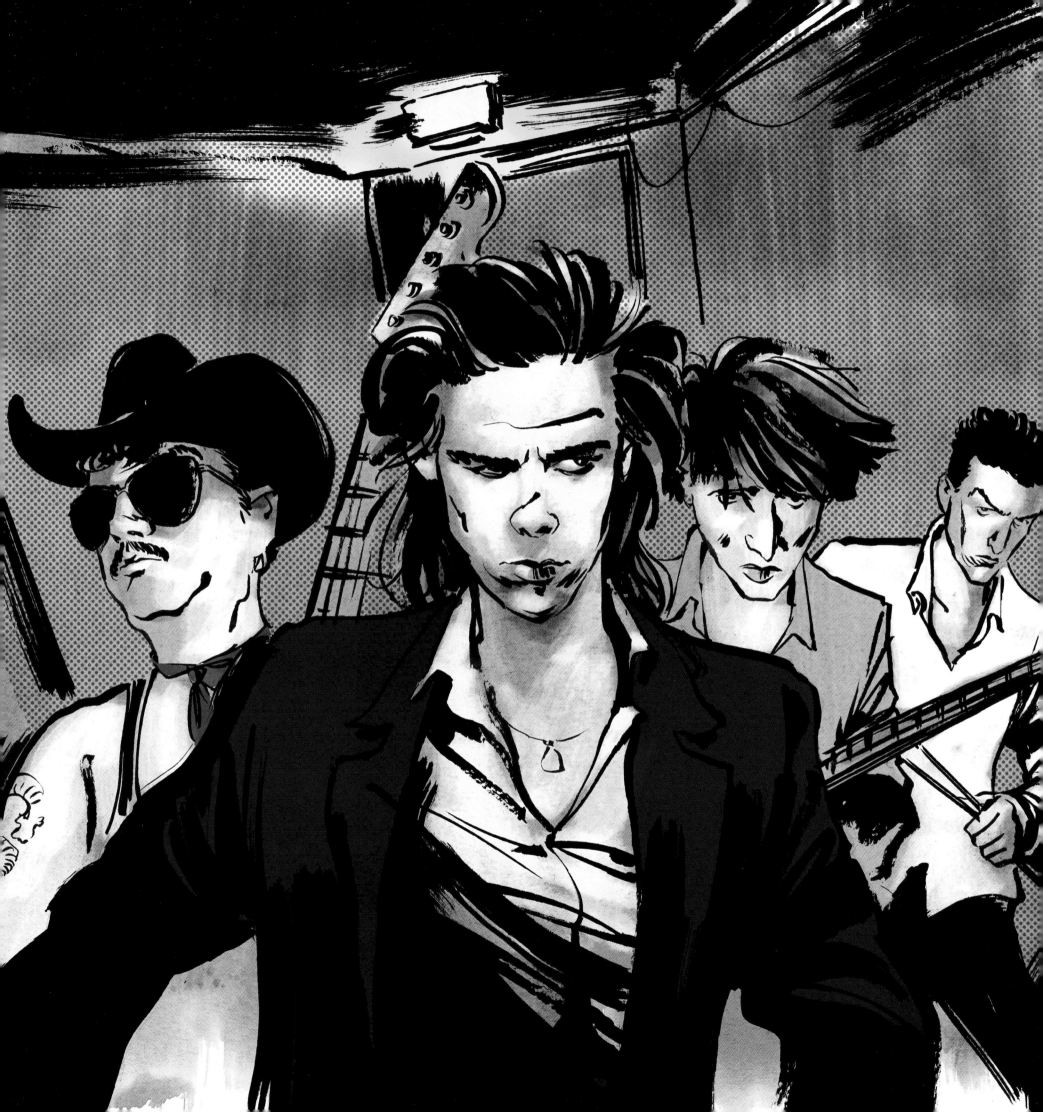

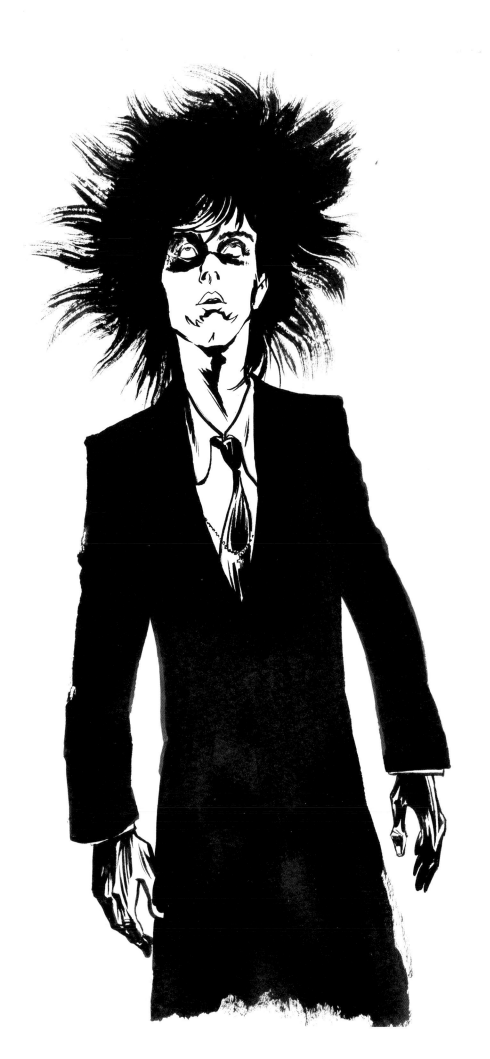

Illustration for *Tupelo*. ▶

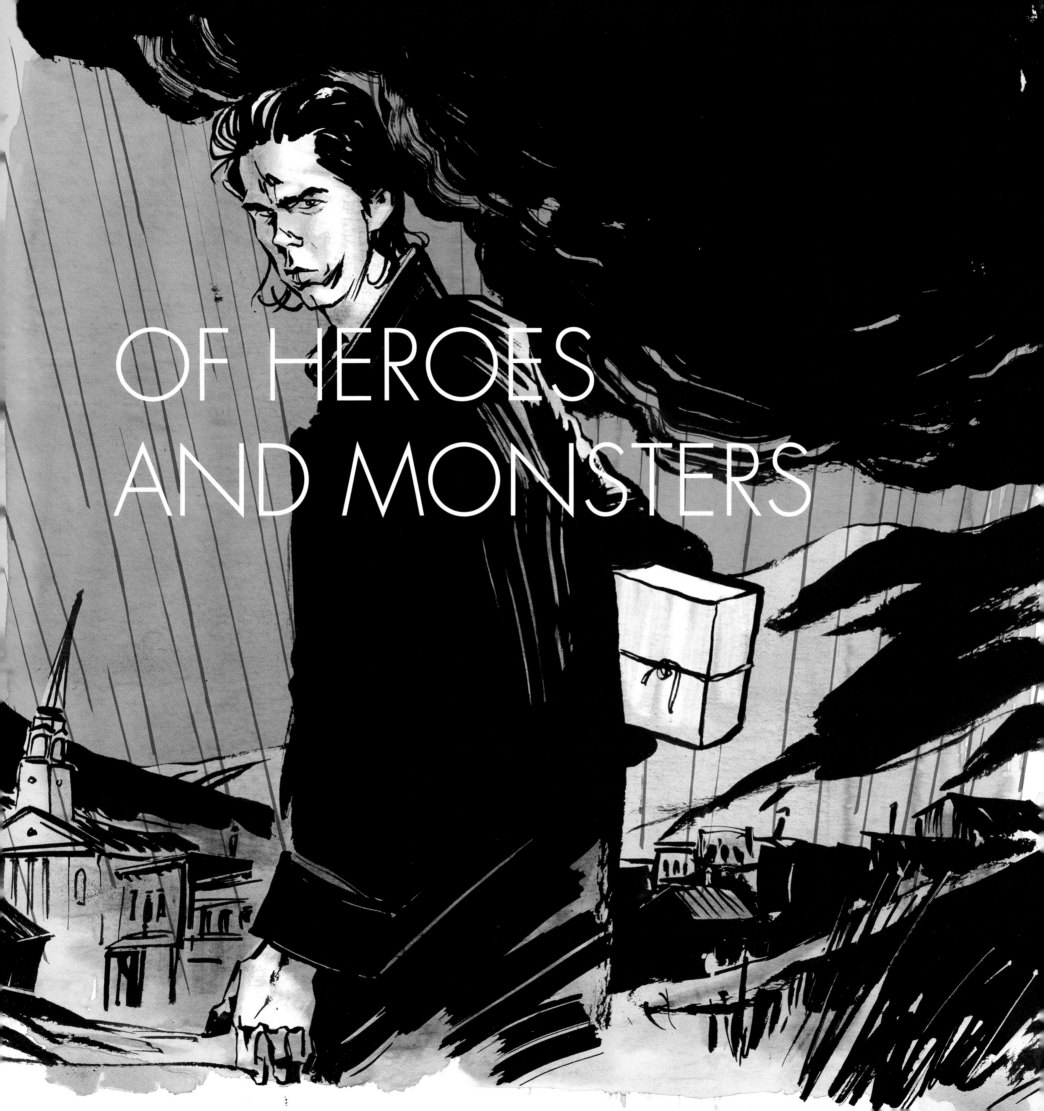

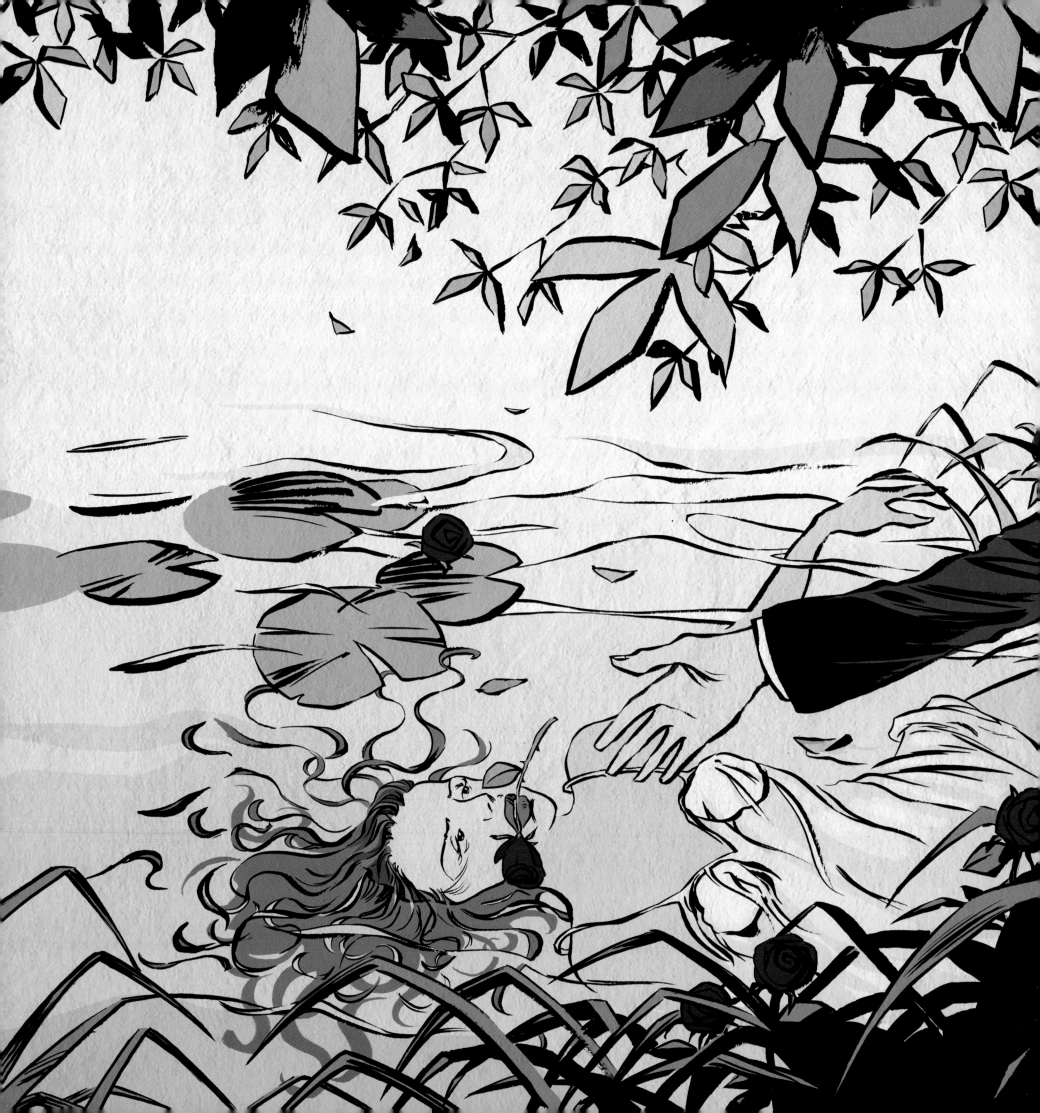

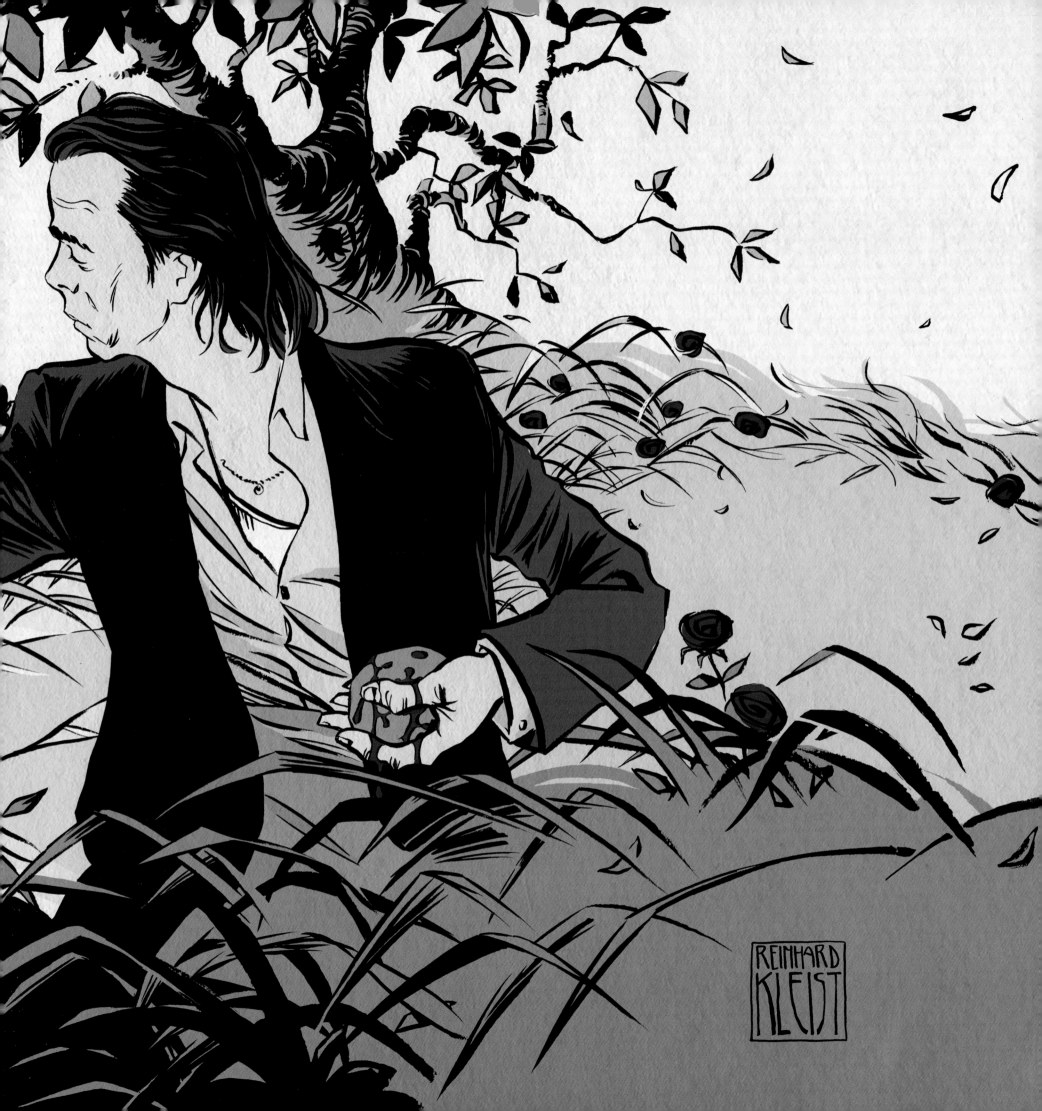

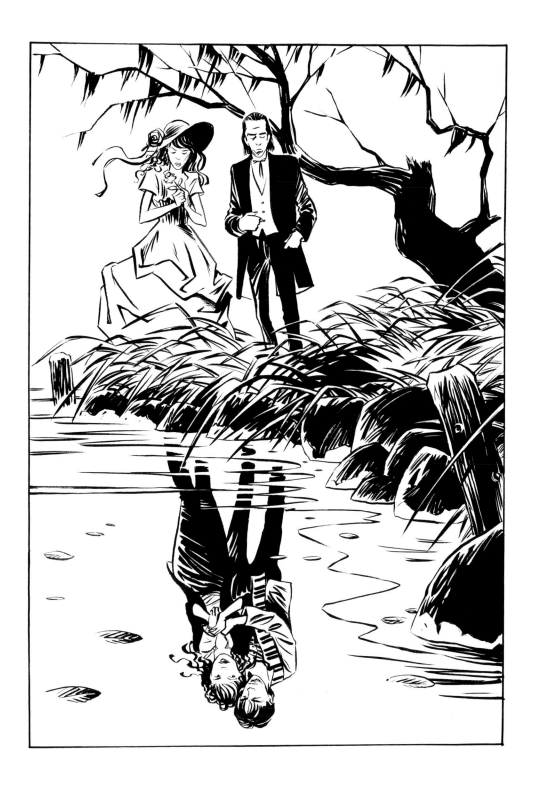

Discarded page from the graphic novel *Mercy on Me*: Elisa Day tells her future murderer about a young couple called Anita Lane and Nick Cave.

◄◄ Illustration for *Where the Wild Roses Grow*, in which the young woman Elisa Day is beaten to death by her lover to the words "All beauty must die".

Nick Cave and PJ Harvey as the fateful lovers from *Henry Lee*. ►

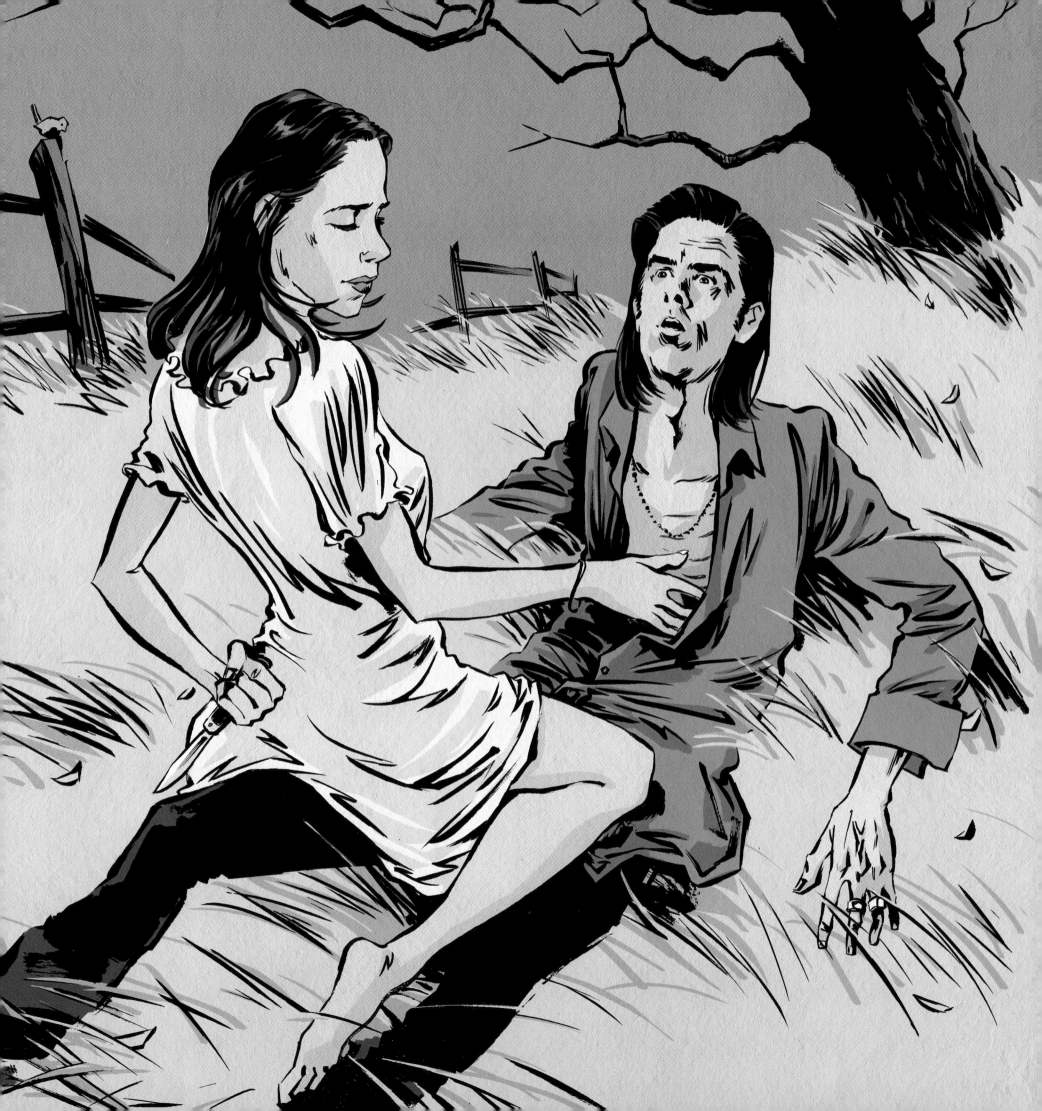

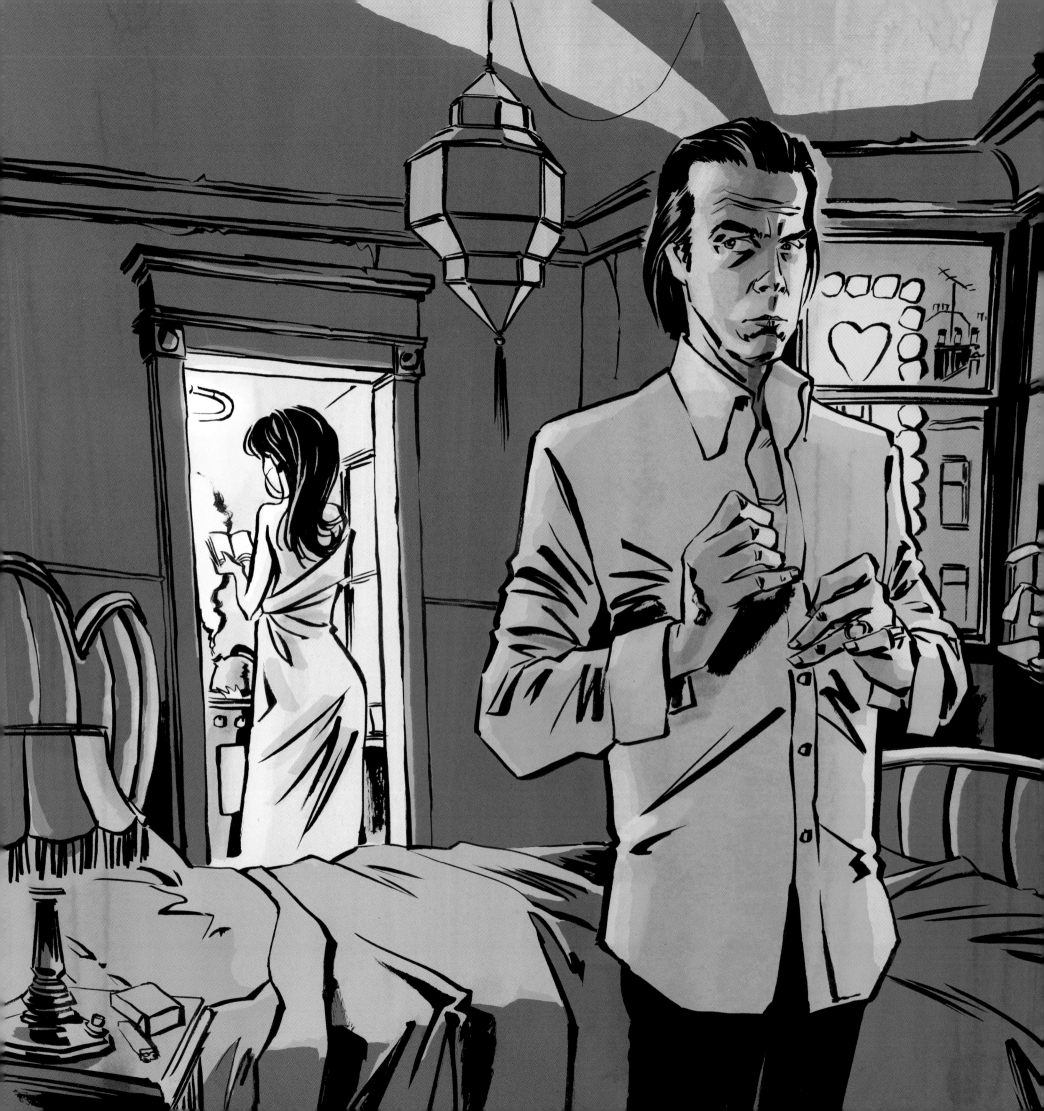

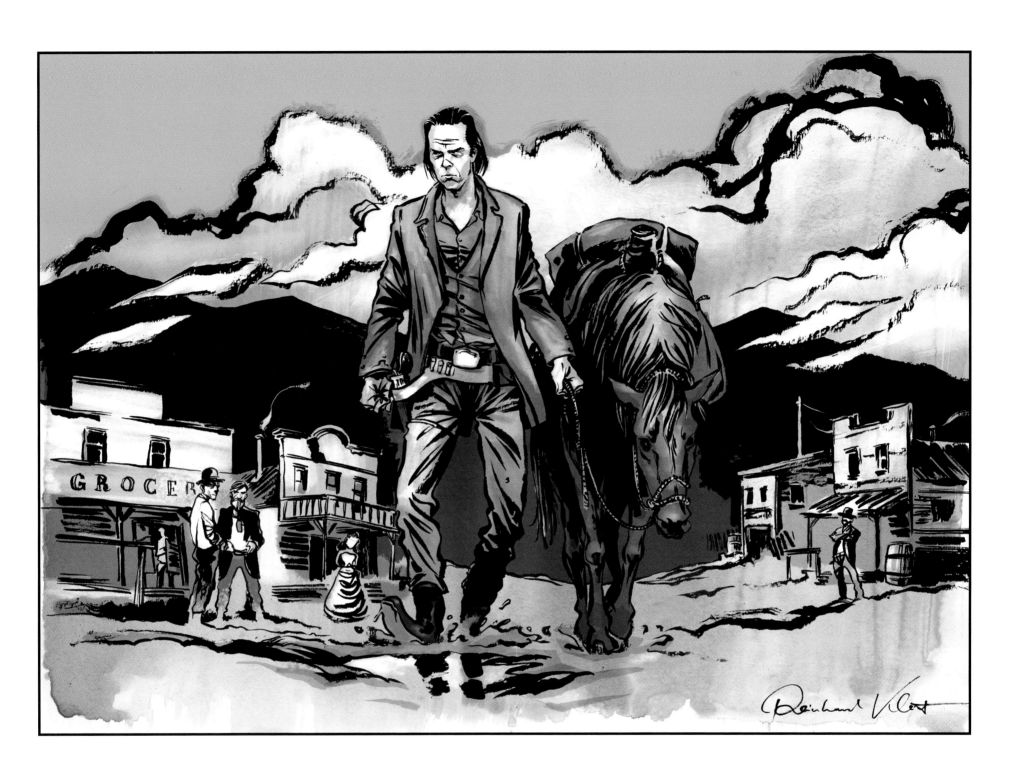

◄ *Jubilee Street* tells of a young prostitute and her best customer.

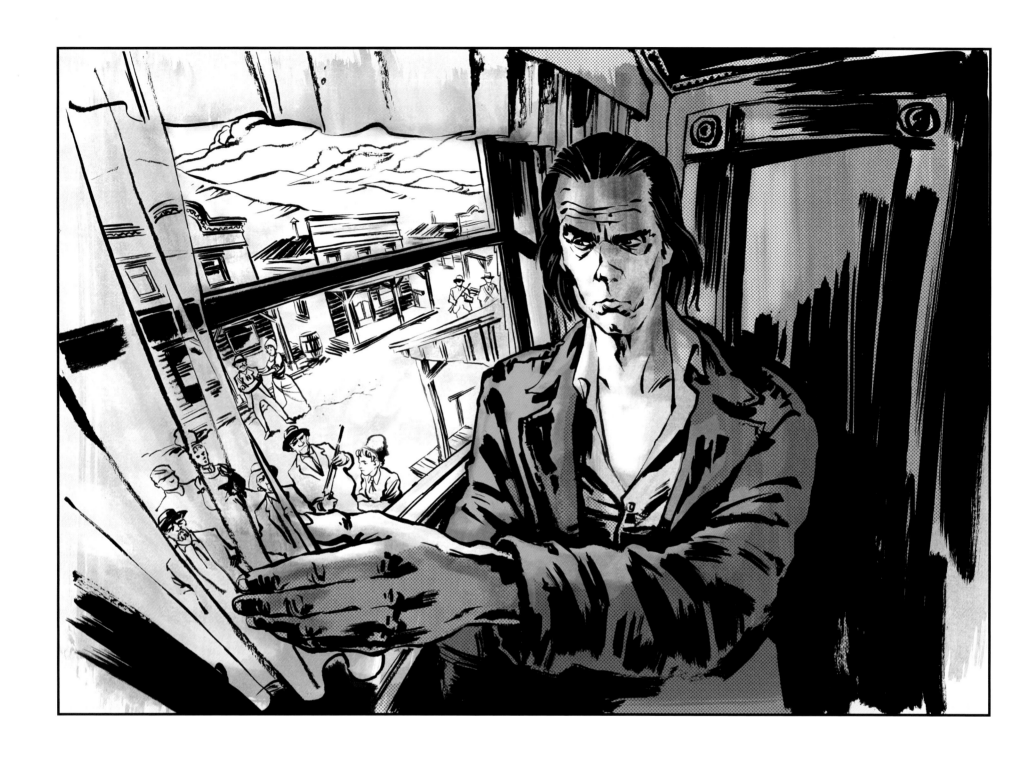

Nick Cave as a stranger who is eyed with suspicion by
the residents of a nameless backwater.

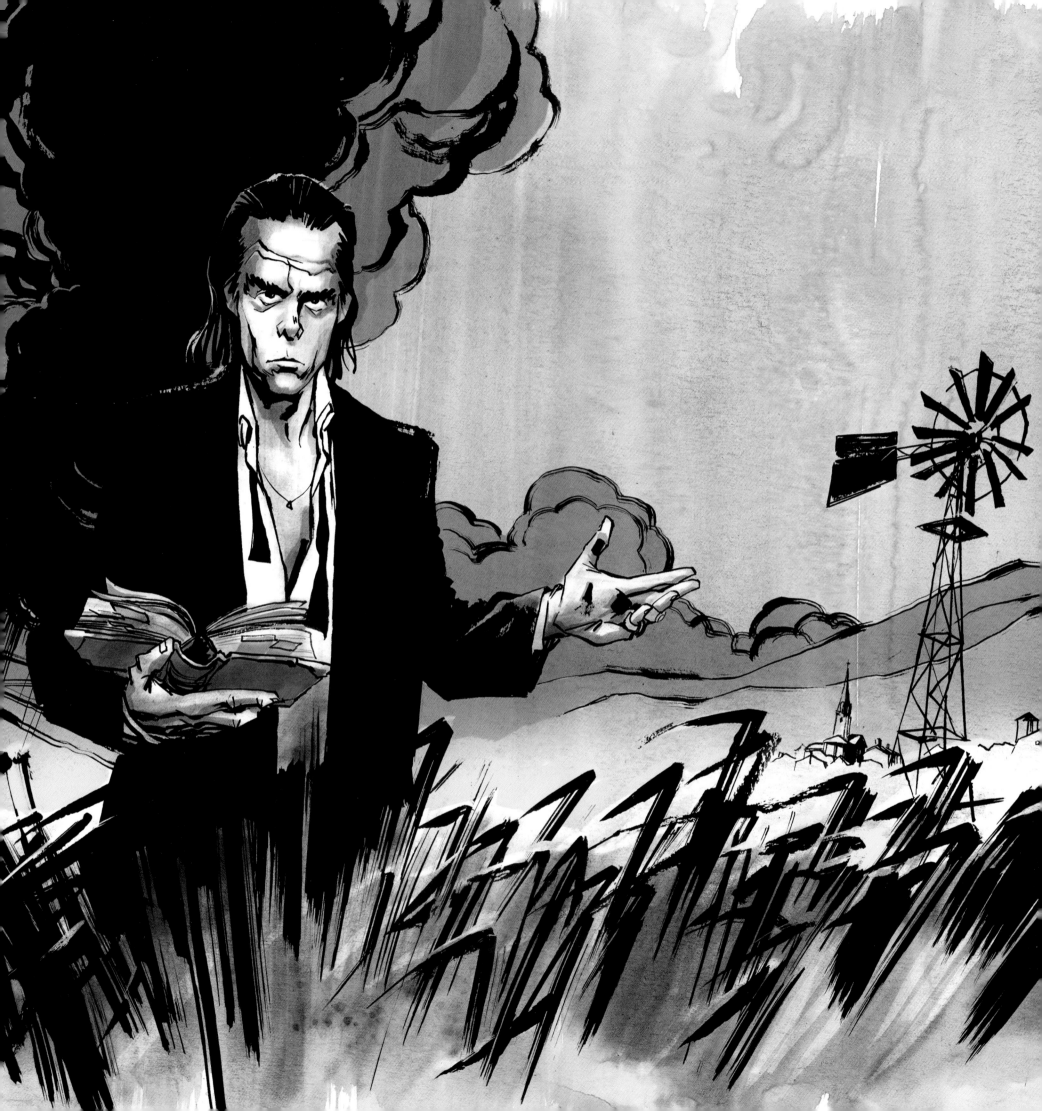

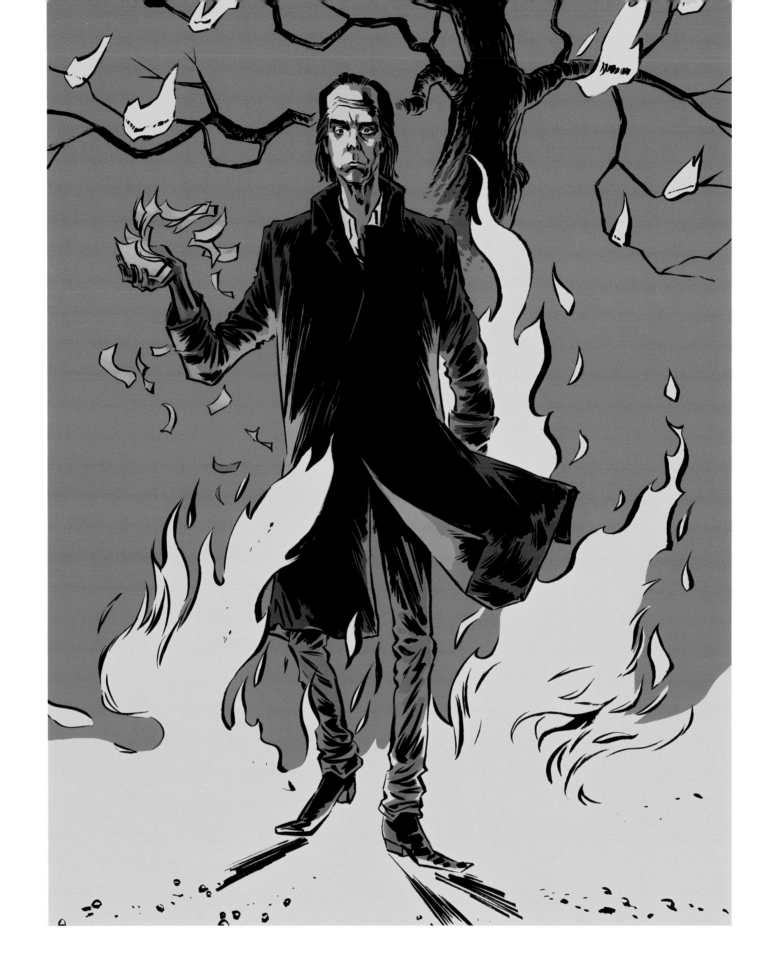

Red Right Hand.

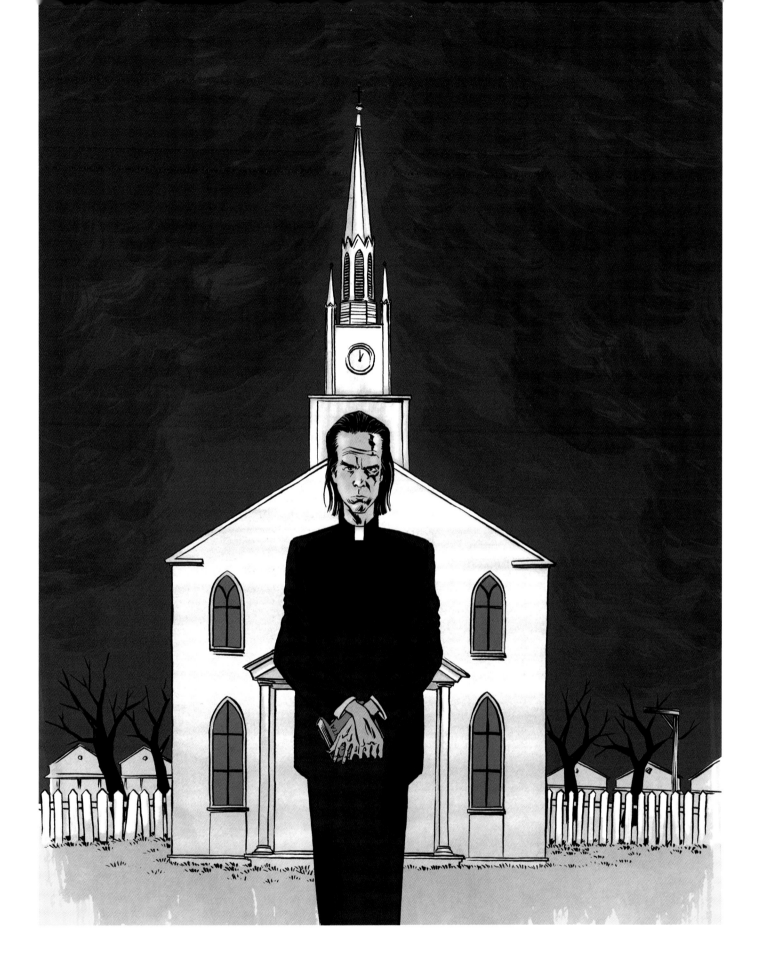

As the priest of the bigoted town in *God Is In The House*.

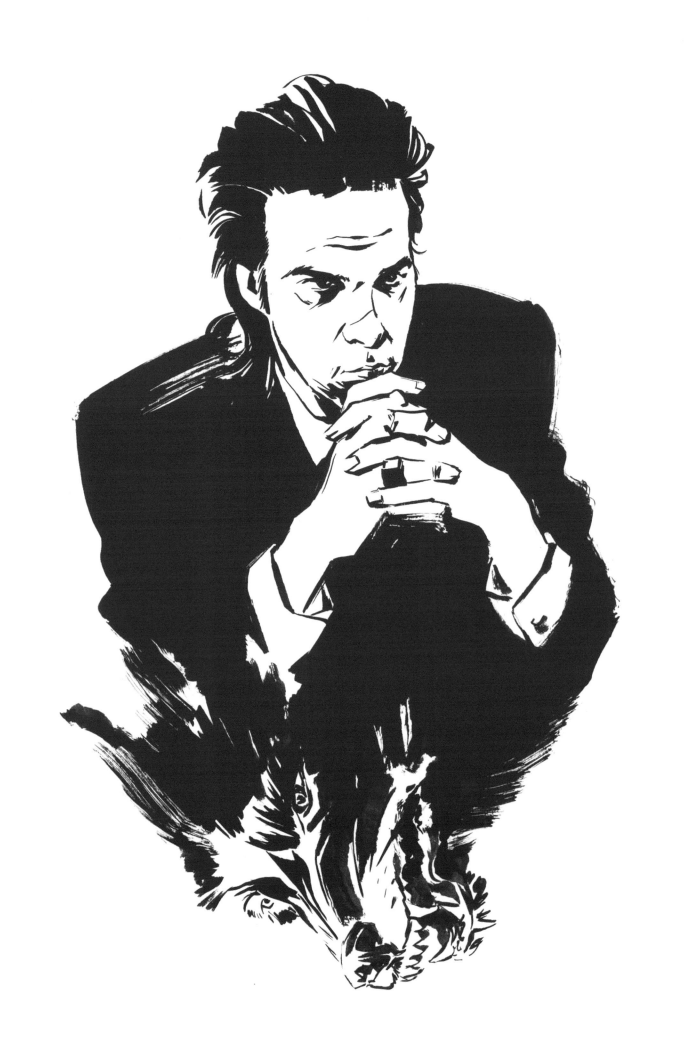

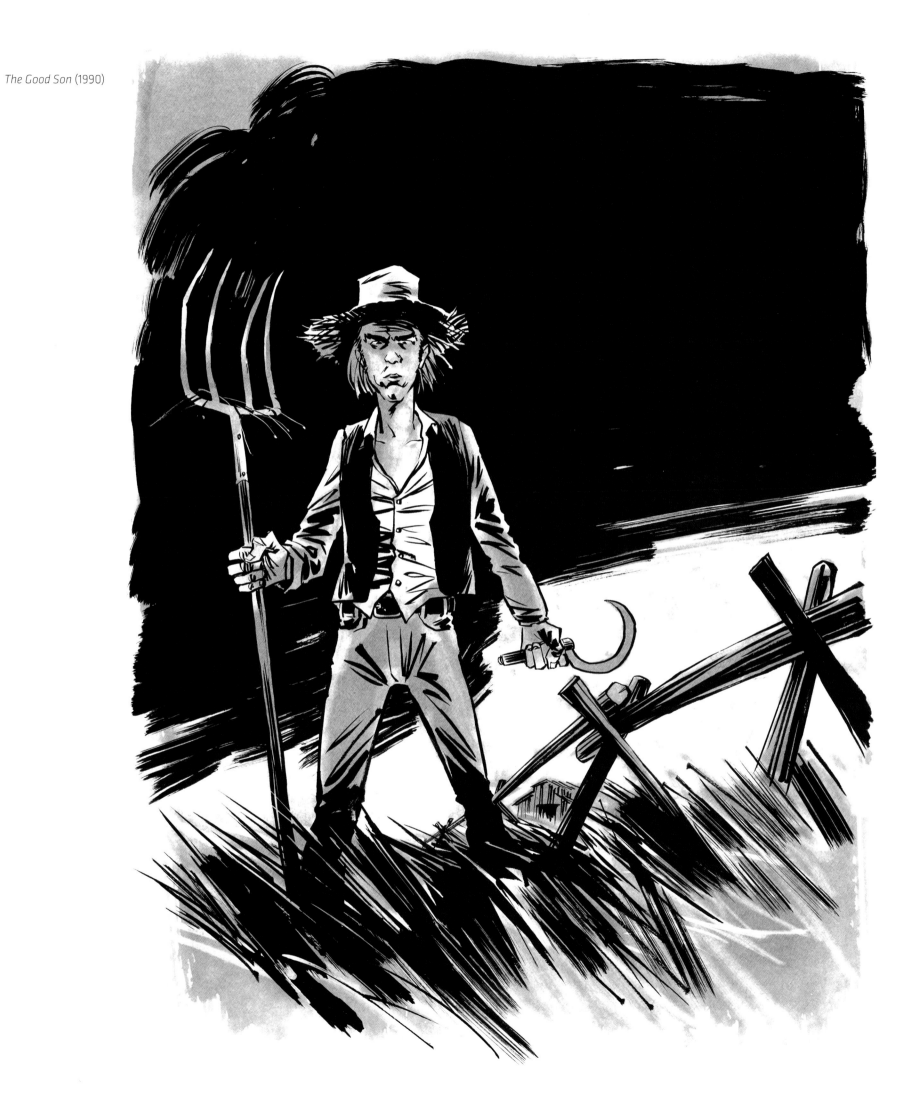

The Good Son (1990)

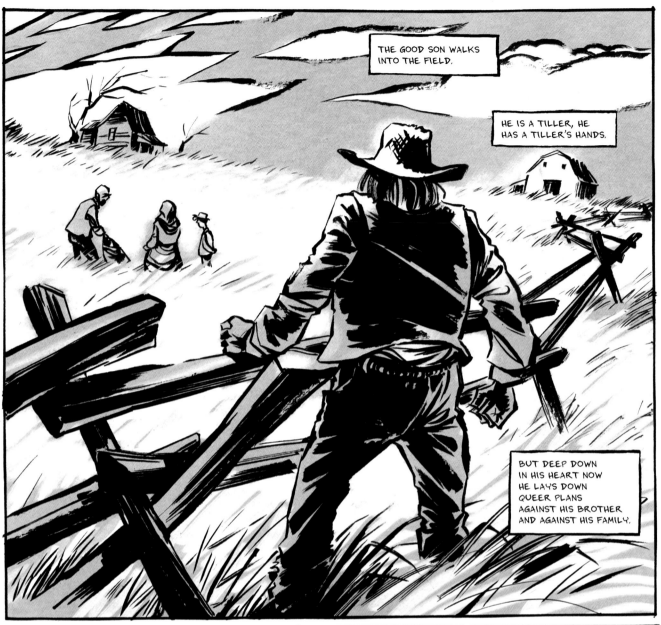

THE GOOD SON WALKS INTO THE FIELD.

HE IS A TILLER, HE HAS A TILLER'S HANDS.

BUT DEEP DOWN IN HIS HEART NOW HE LAYS DOWN QUEER PLANS AGAINST HIS BROTHER AND AGAINST HIS FAMILY.

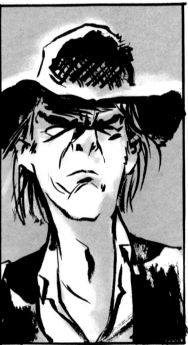

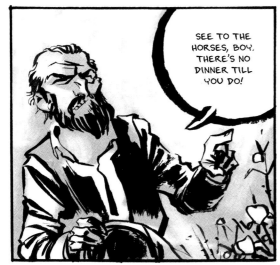

SEE TO THE HORSES, BOY, THERE'S NO DINNER TILL YOU DO!

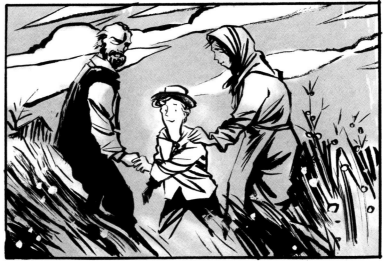

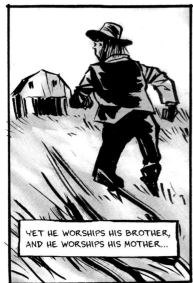

YET HE WORSHIPS HIS BROTHER, AND HE WORSHIPS HIS MOTHER...

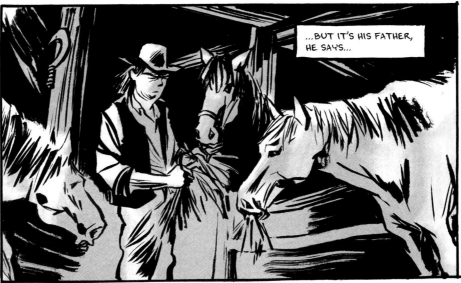

...BUT IT'S HIS FATHER, HE SAYS...

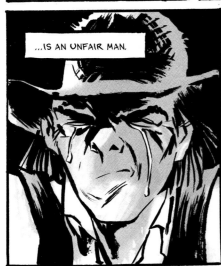

...IS AN UNFAIR MAN.

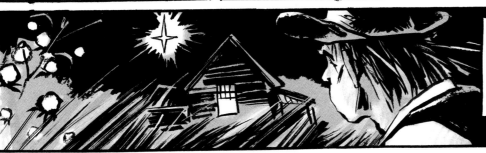

THE GOOD SON HAS SAT AND OFTEN WEPT BENEATH A MALIGN STAR BY WHICH HE'S KEPT, AND THE NIGHT-TIME IN WHICH HE'S WRAPPED SPEAKS OF GOOD AND SPEAKS OF EVIL.

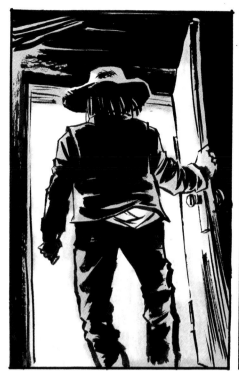

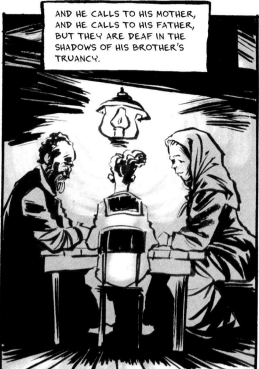

AND HE CALLS TO HIS MOTHER, AND HE CALLS TO HIS FATHER, BUT THEY ARE DEAF IN THE SHADOWS OF HIS BROTHER'S TRUANCY.

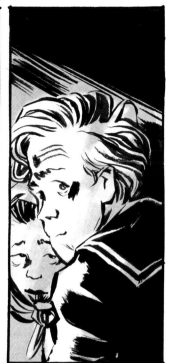

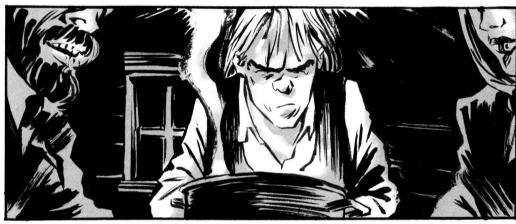

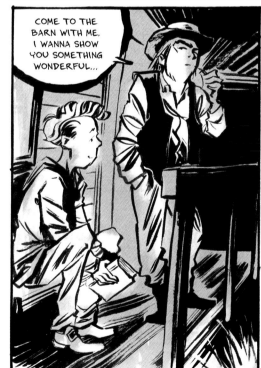

COME TO THE BARN WITH ME. I WANNA SHOW YOU SOMETHING WONDERFUL...

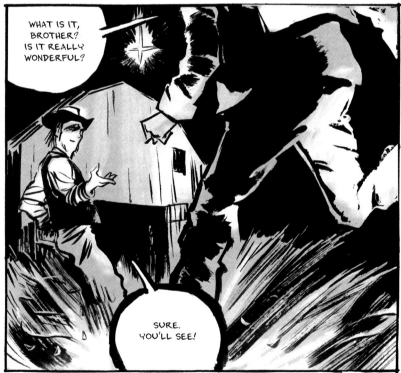

WHAT IS IT, BROTHER? IS IT REALLY WONDERFUL?

SURE. YOU'LL SEE!

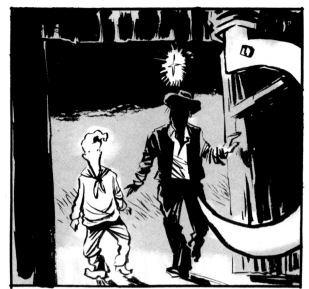
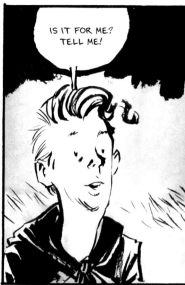
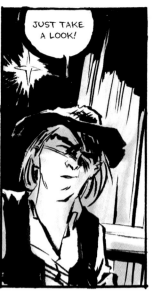
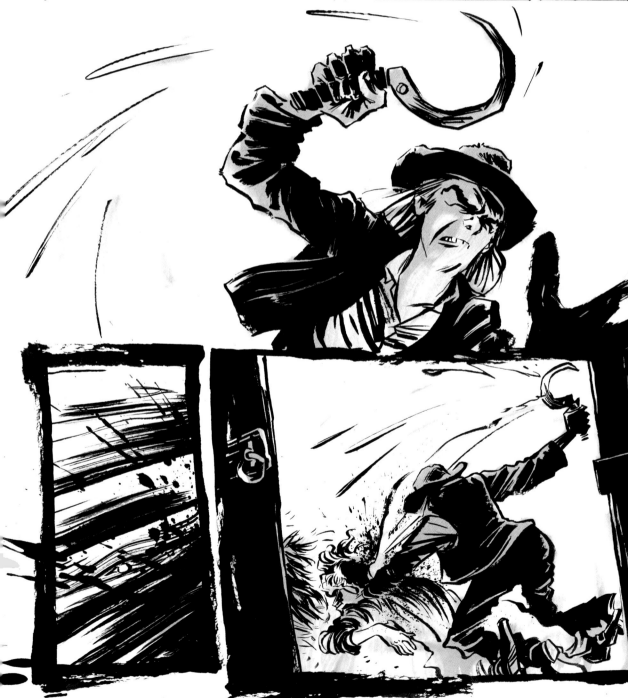

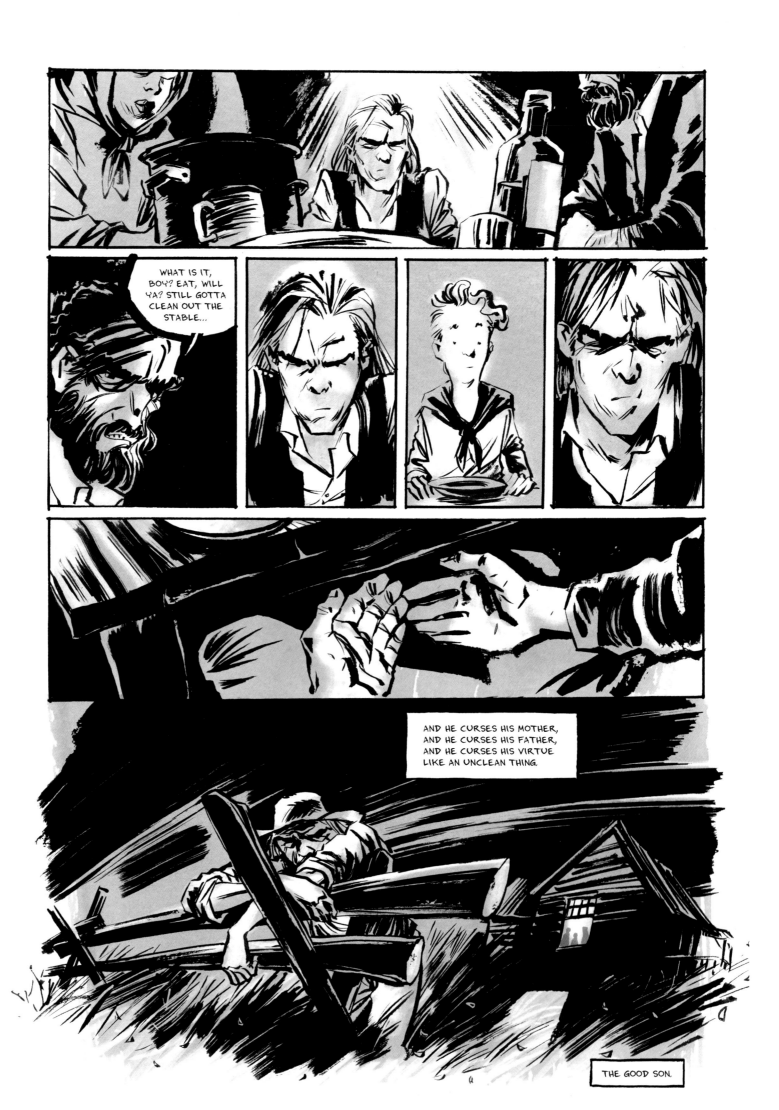

OF FIRE AND NOISE –
THE BAD SEEDS

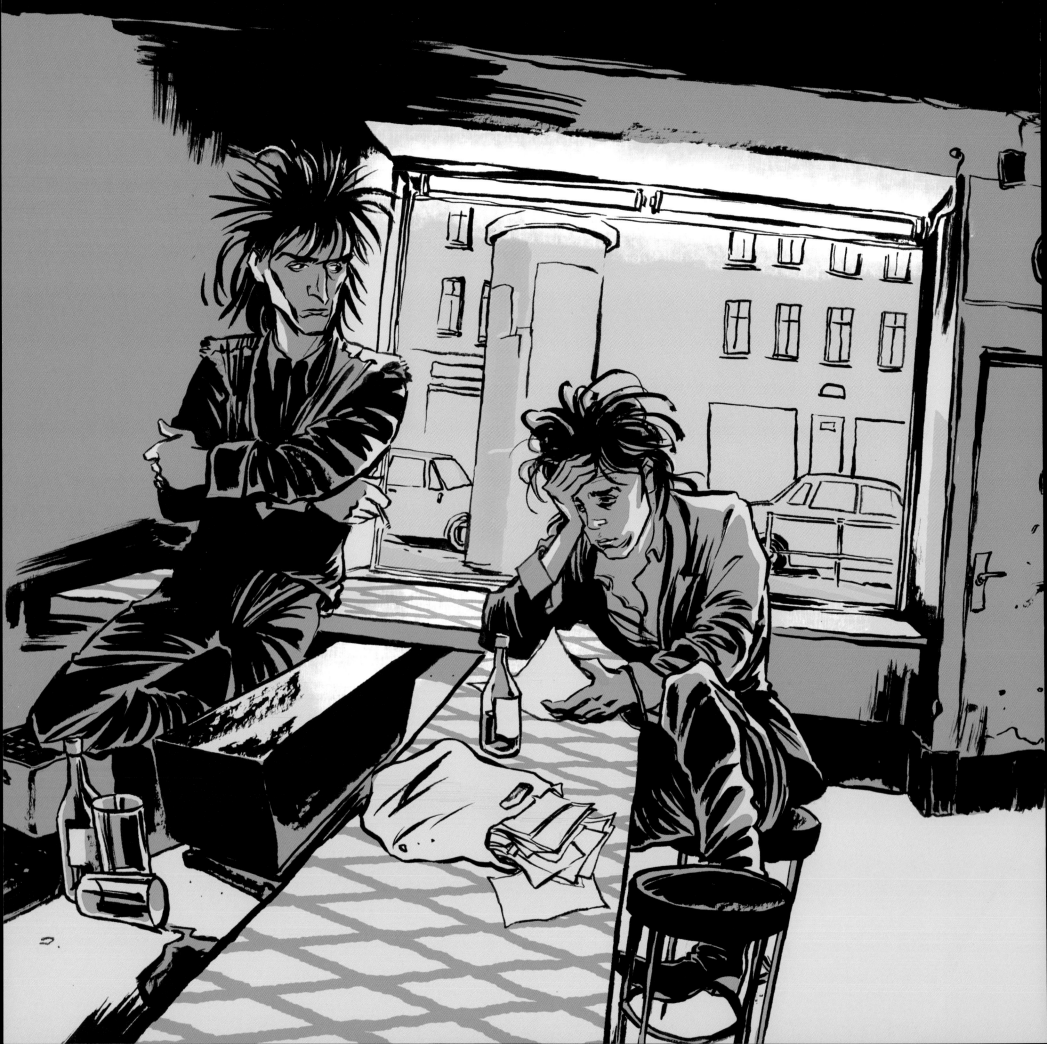

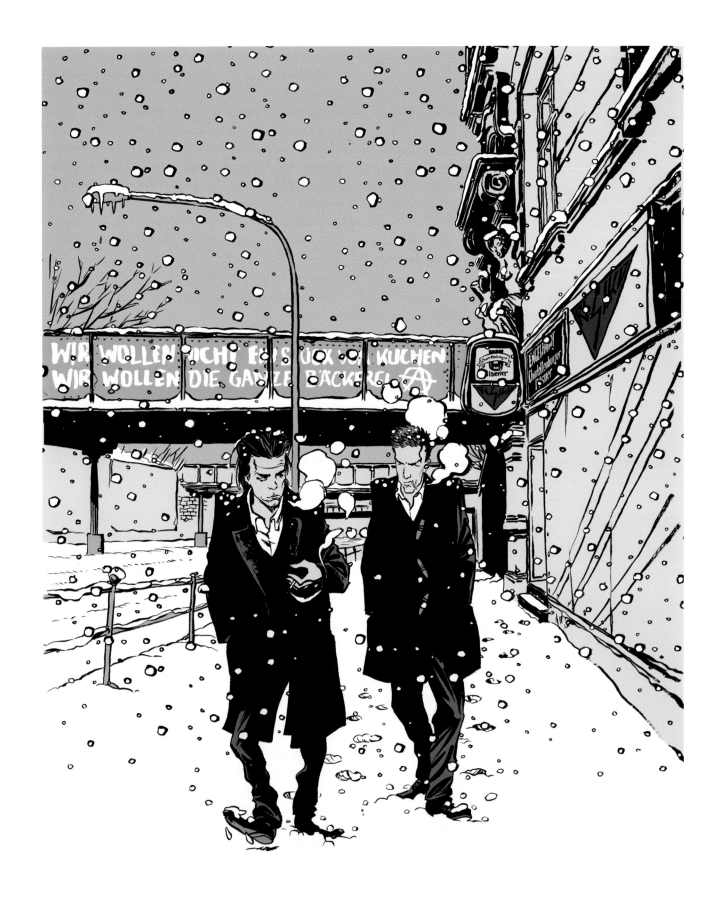

Mick Harvey and Nick Cave leaving the Risiko.

◄◄ Daybreak at the Berlin bar Risiko – Blixa Bargeld behind
the bar. On the bar, manuscript pages that Nick Cave will likely
soon leave there.

Nick Cave in the mid-eighties in his apartment share in
Berlin Kreuzberg. ►

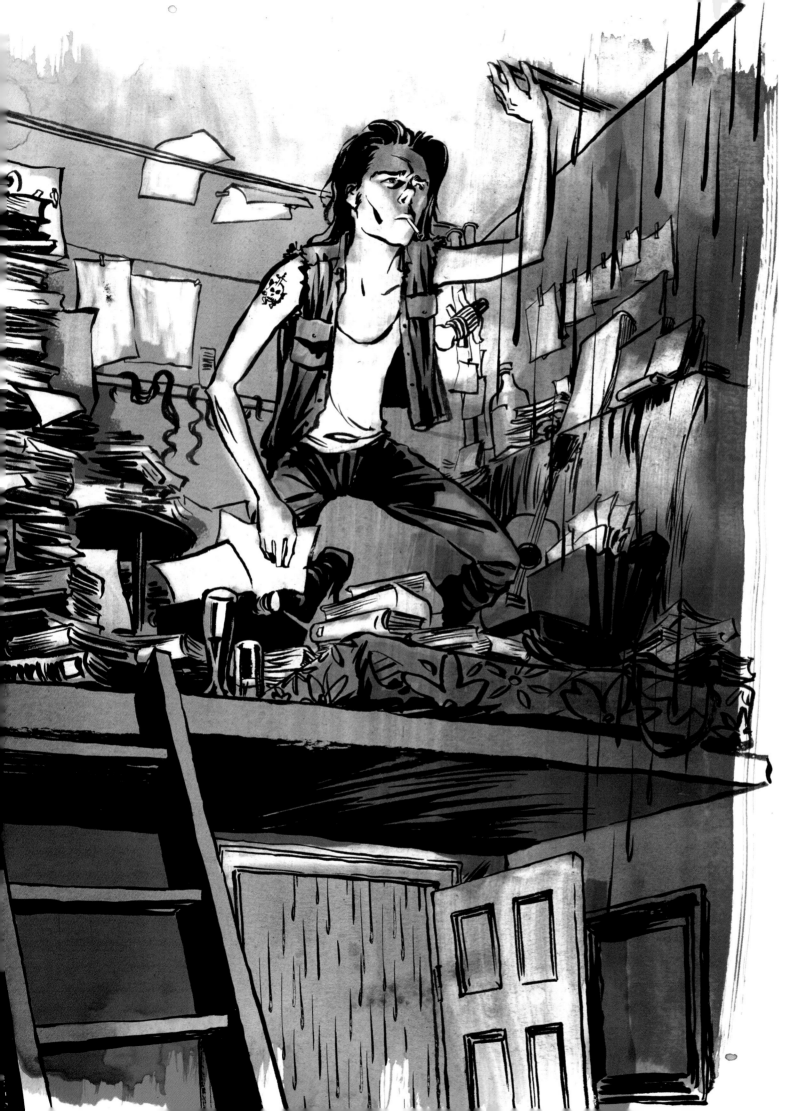

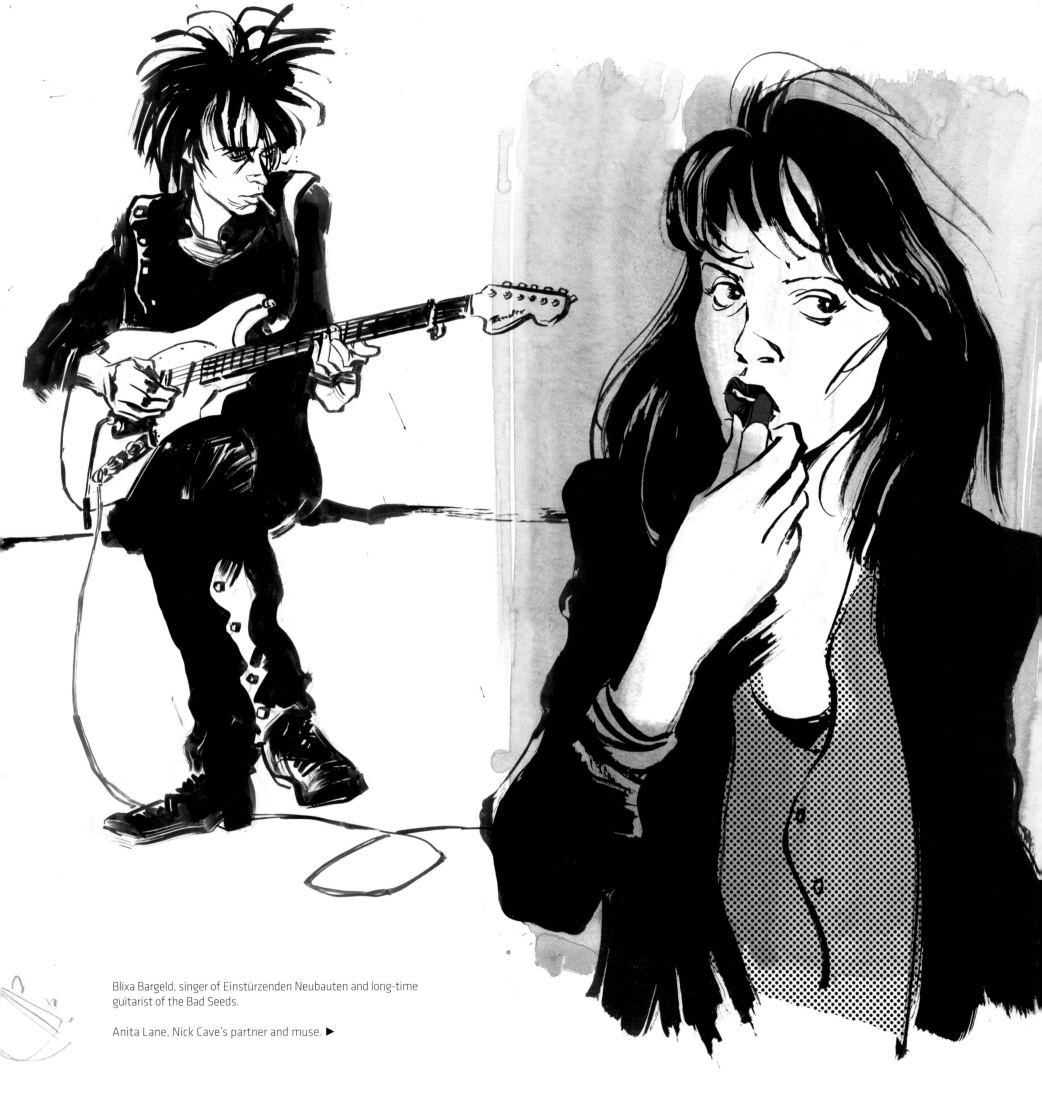

Blixa Bargeld, singer of Einstürzenden Neubauten and long-time guitarist of the Bad Seeds.

Anita Lane, Nick Cave's partner and muse. ▶

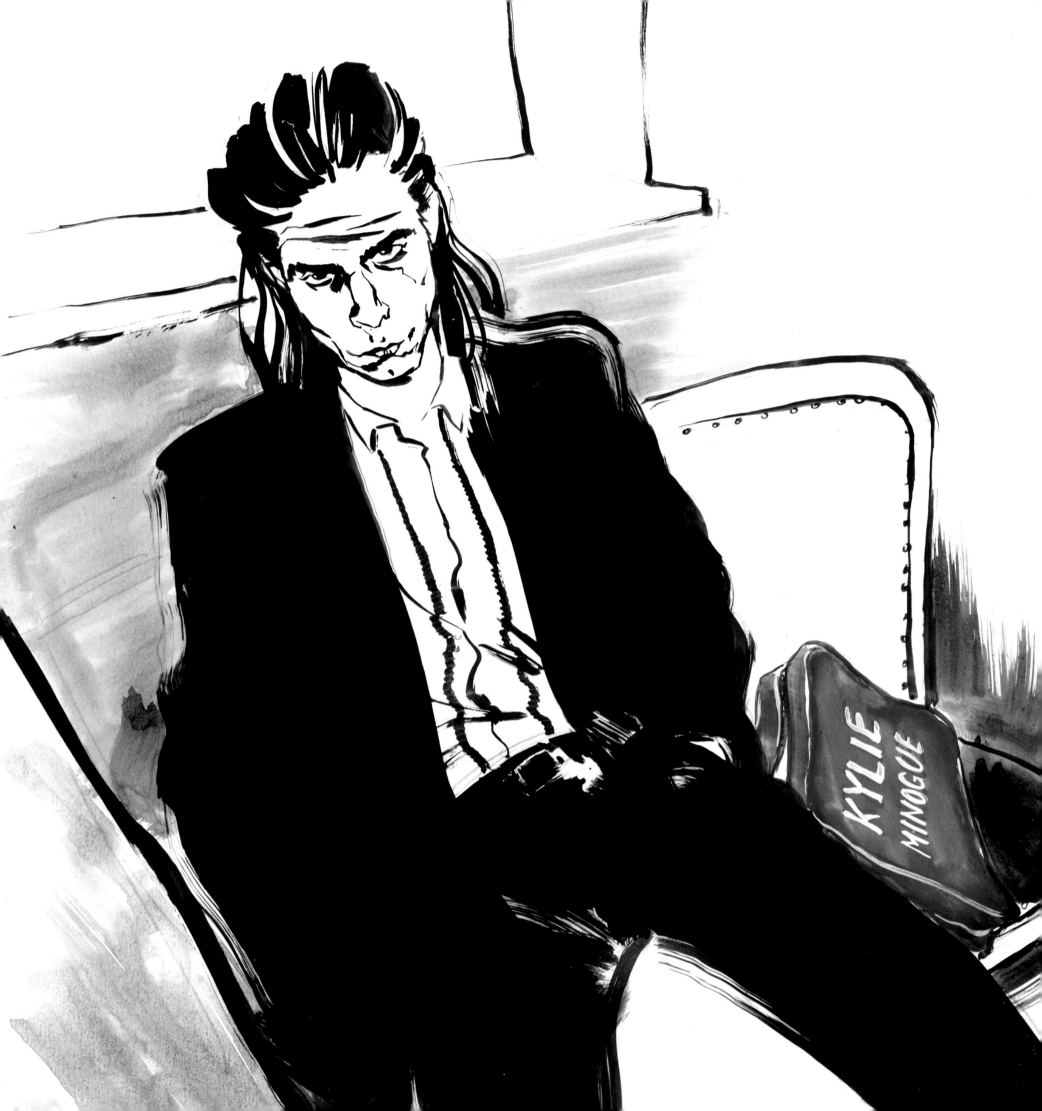

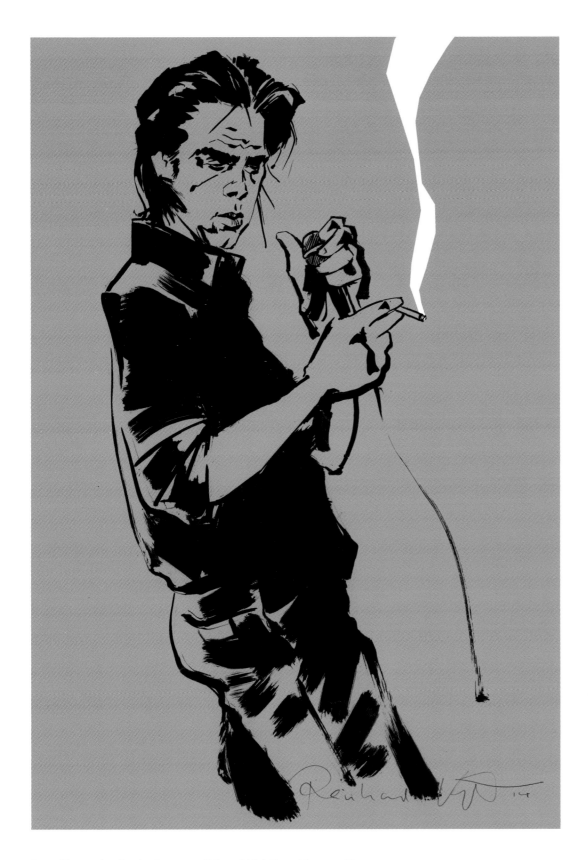

Cover illustration for the German edition of *Nick Cave: Mercy on Me*.

◀ Nick Cave and the Kylie Minogue bag he always had with him
in the mid-nineties.

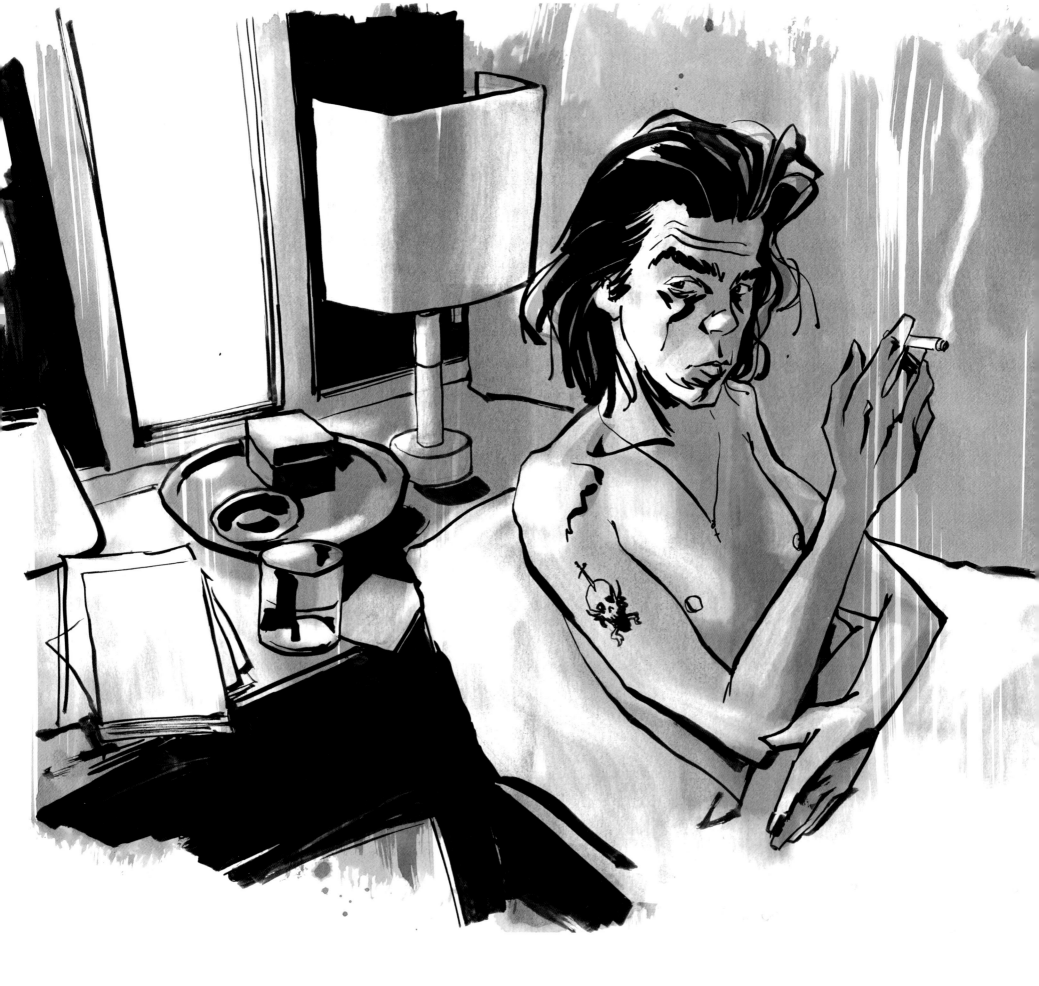

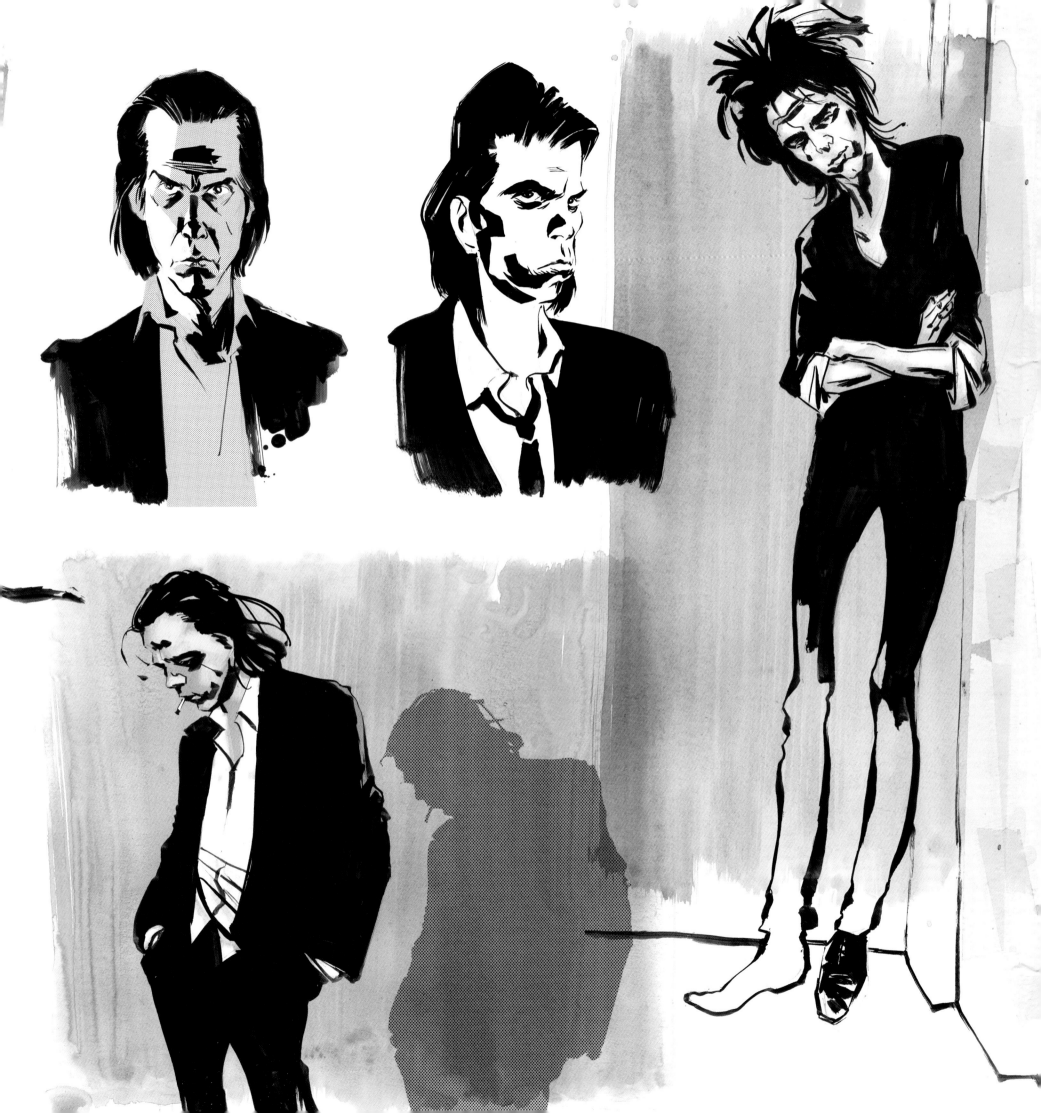

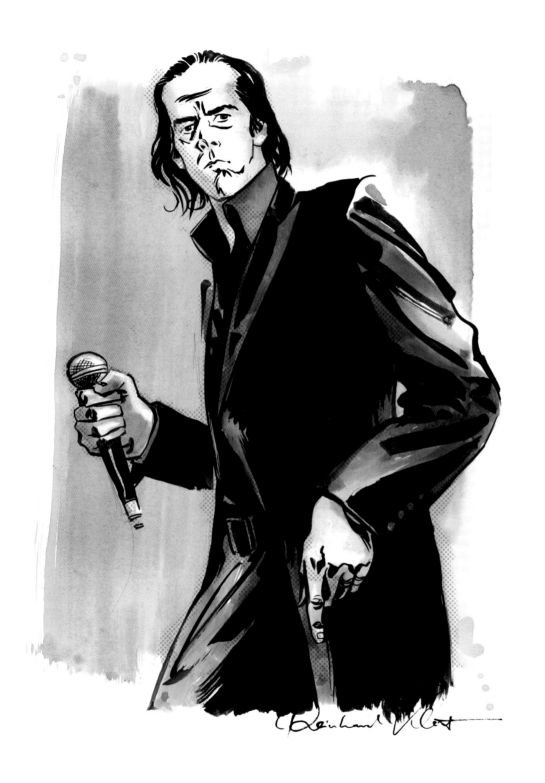

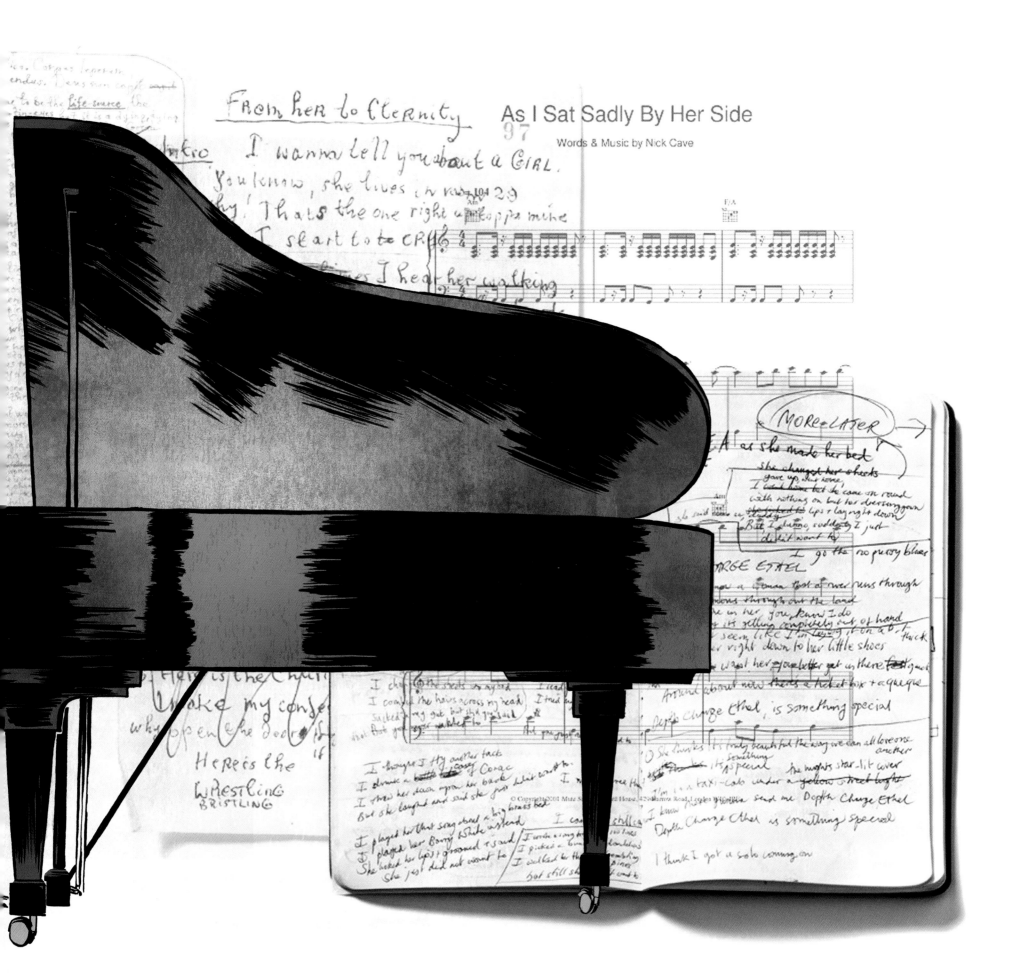

As I Sat Sadly By Her Side

Words & Music by Nick Cave

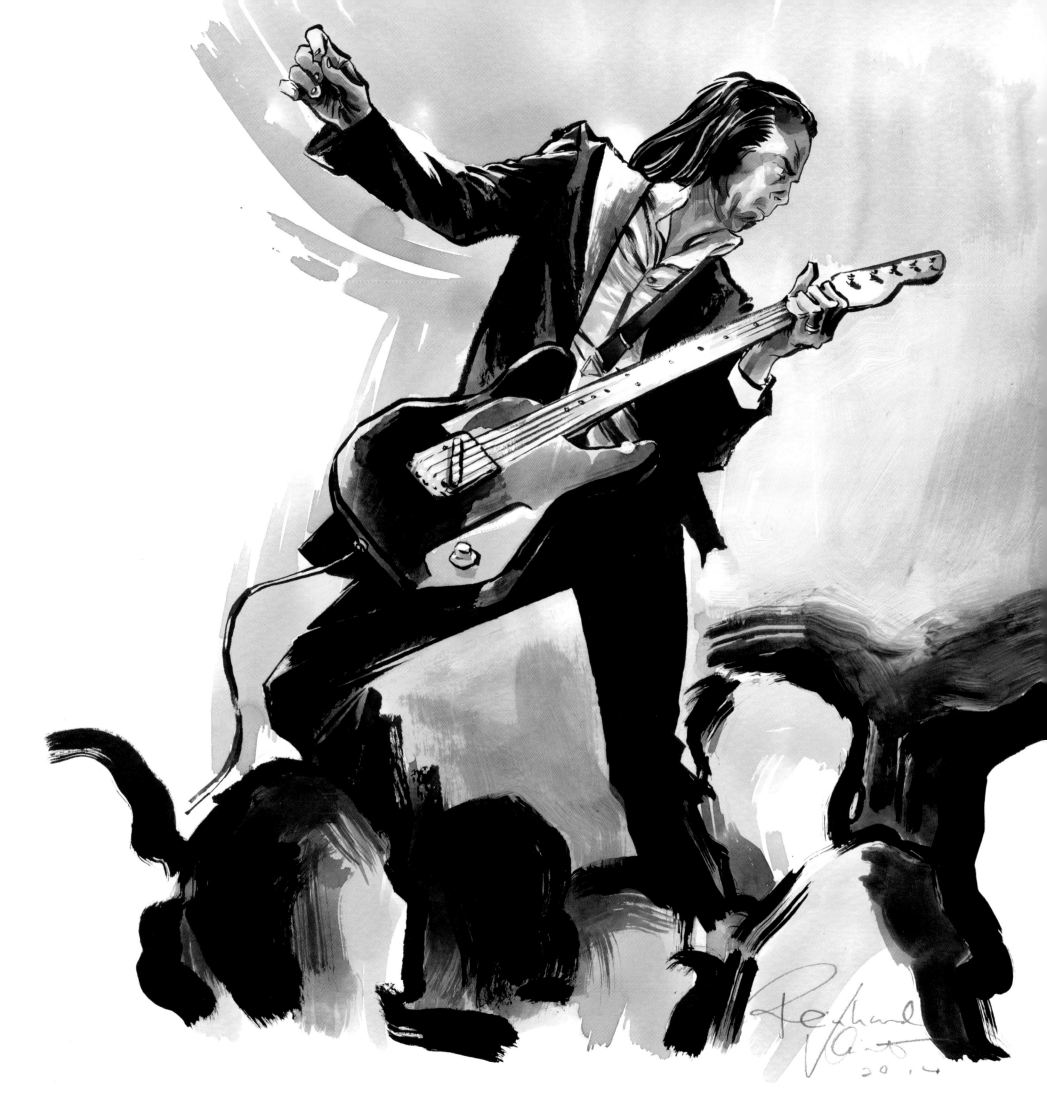

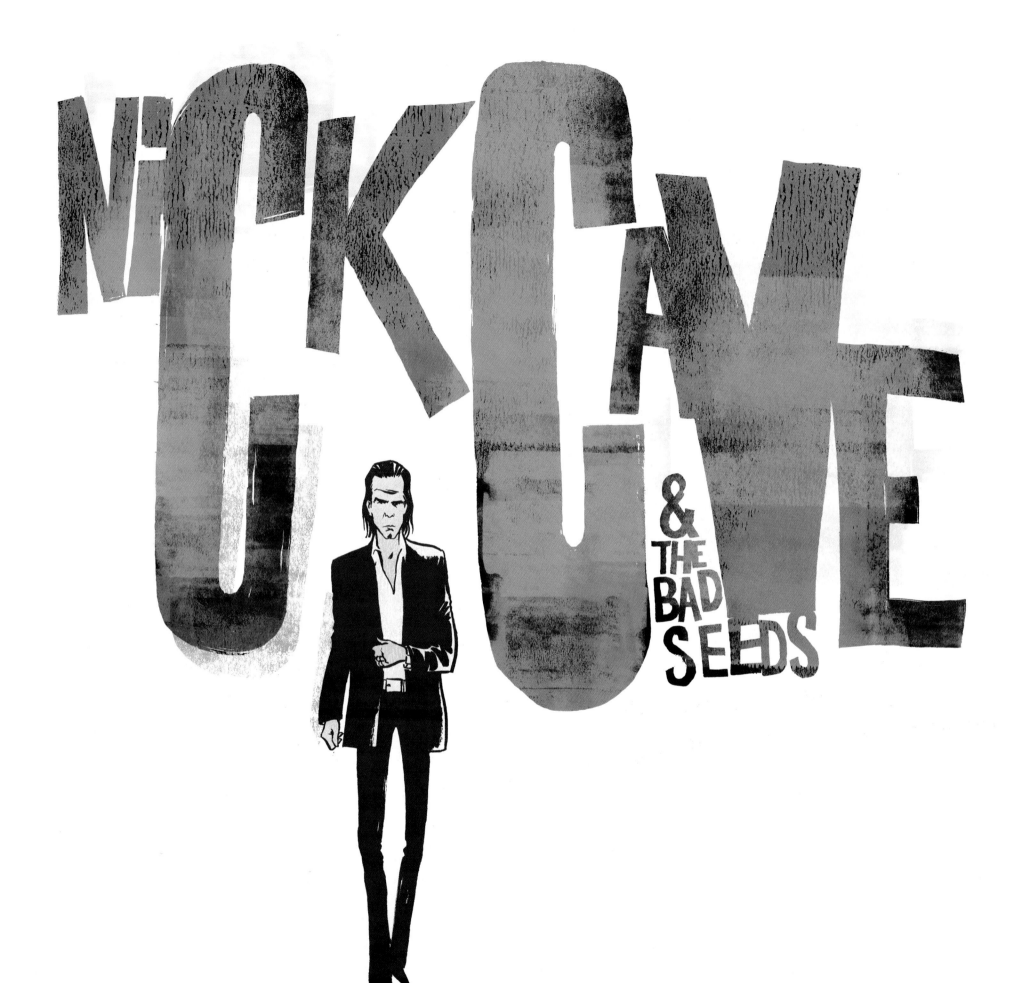

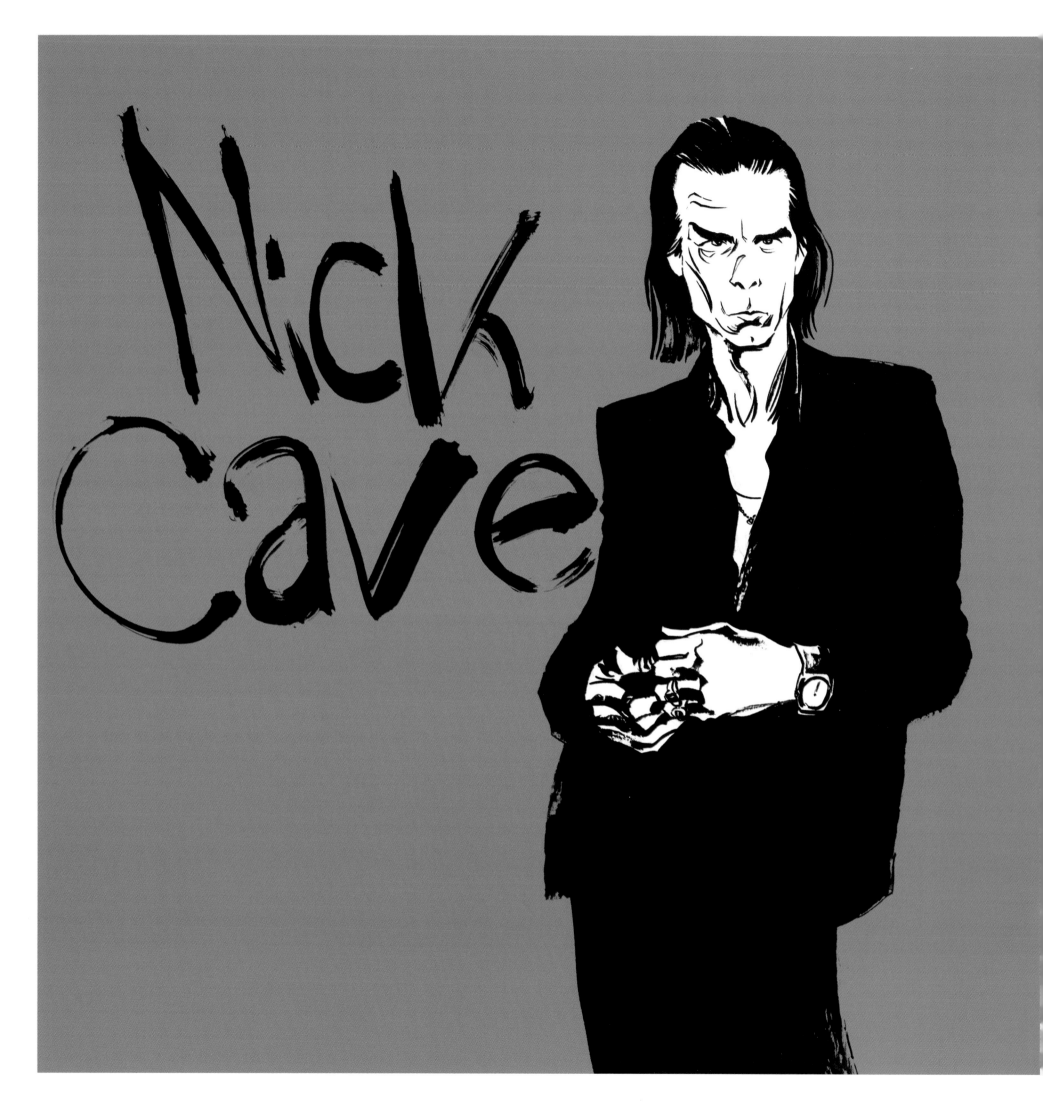

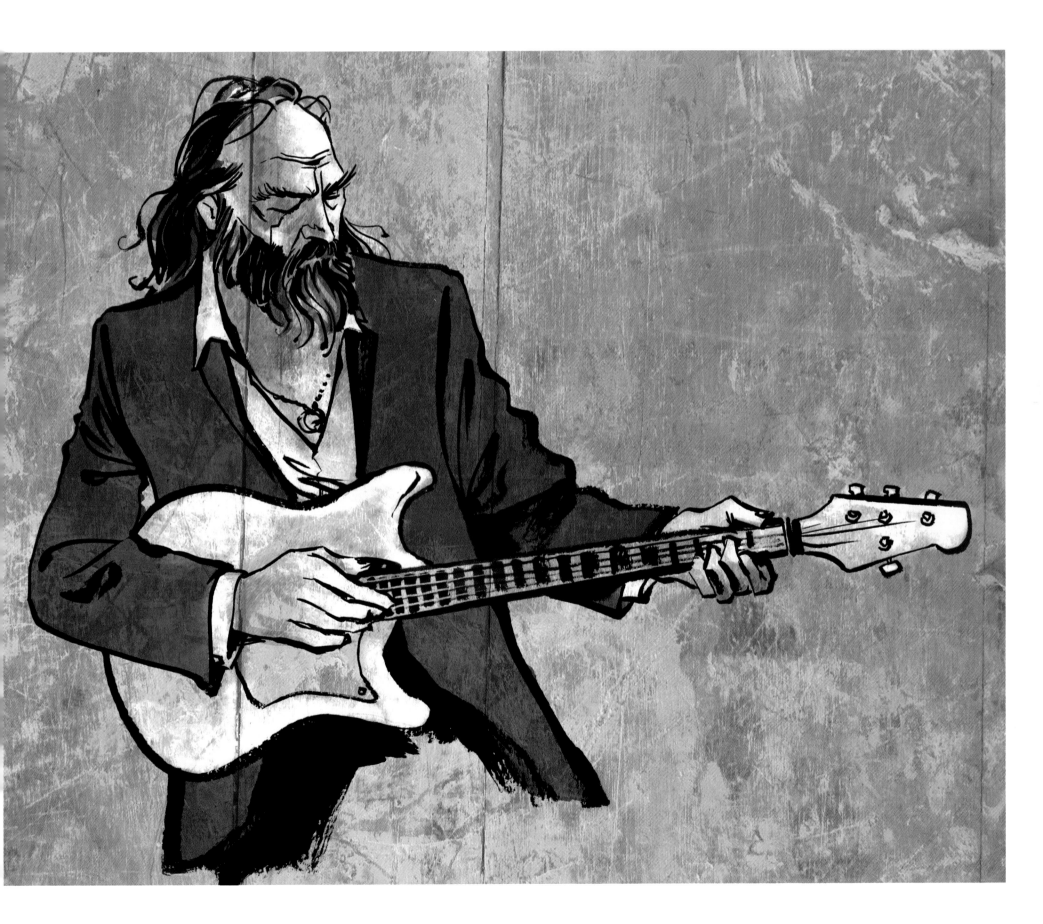

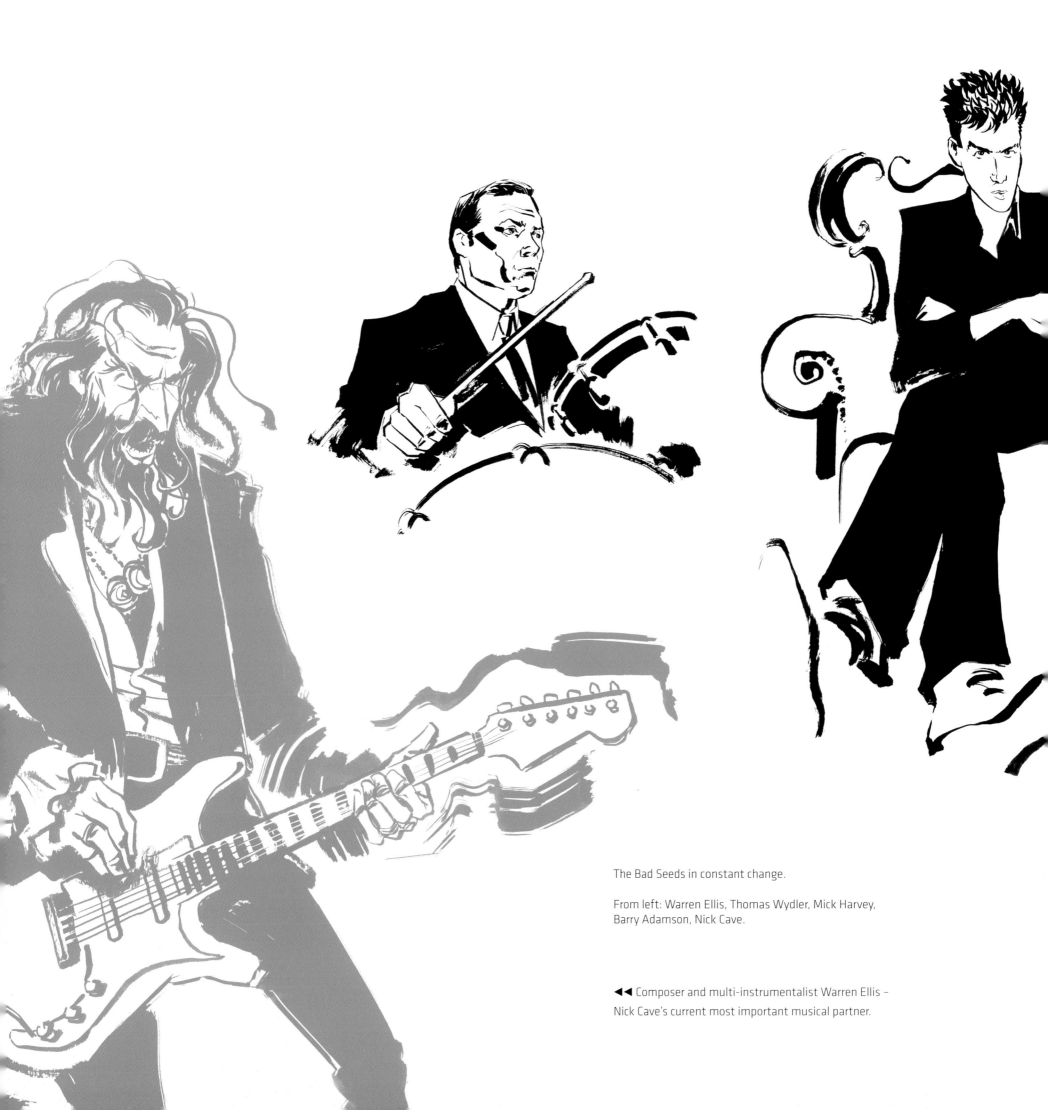

The Bad Seeds in constant change.

From left: Warren Ellis, Thomas Wydler, Mick Harvey,
Barry Adamson, Nick Cave.

◄◄ Composer and multi-instrumentalist Warren Ellis –
Nick Cave's current most important musical partner.

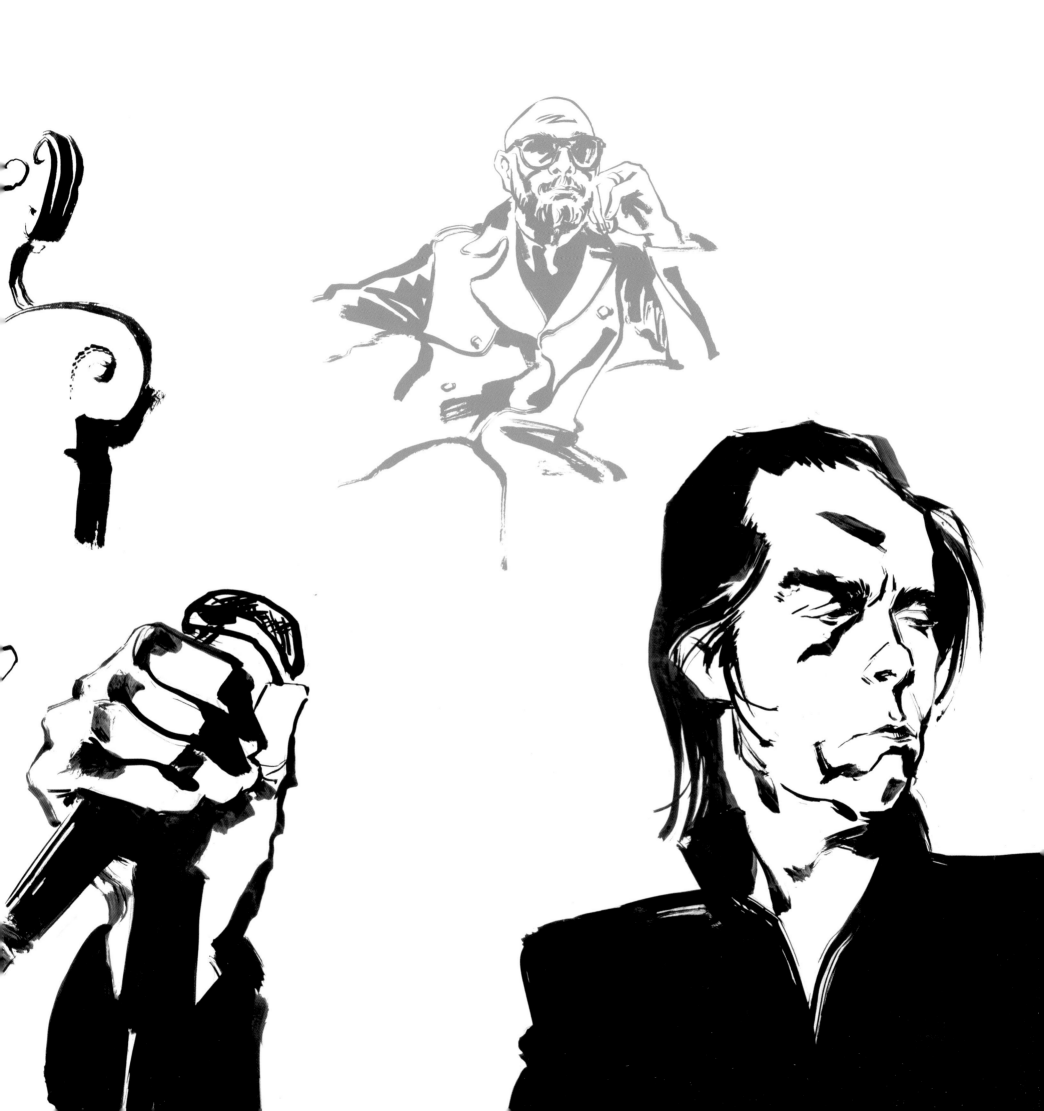

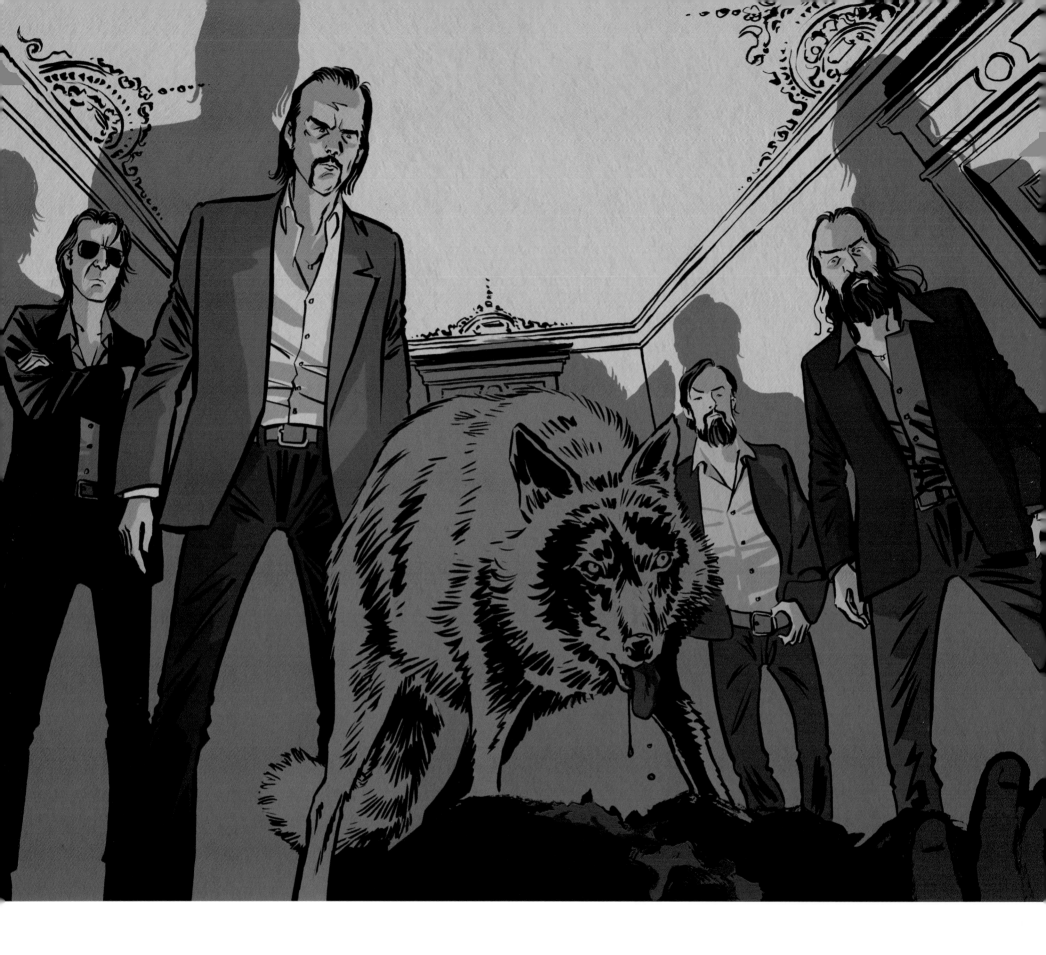

Martyn Casey, Nick Cave, Jim Scalvunos and Warren Ellis are
Grinderman, a side project to the Bad Seeds (2007–2010).

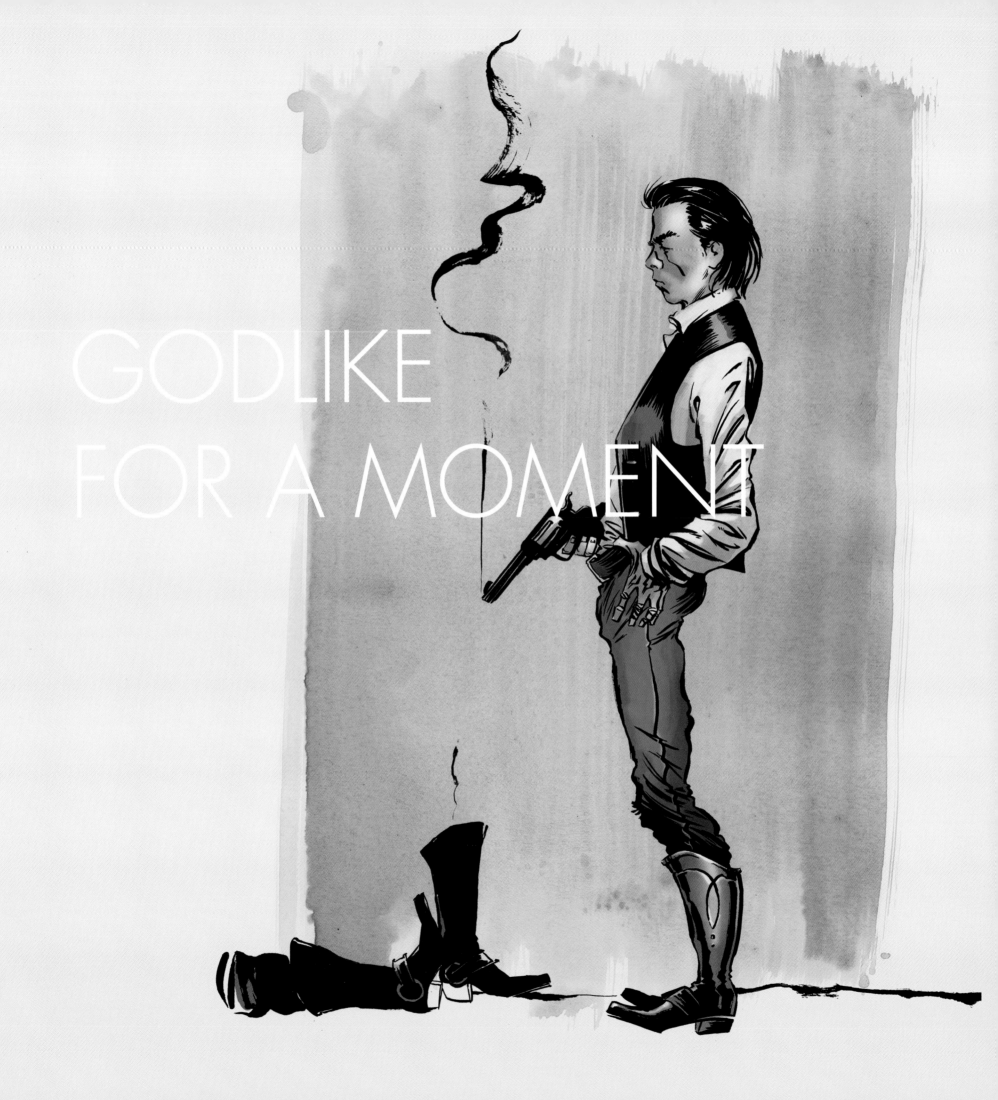

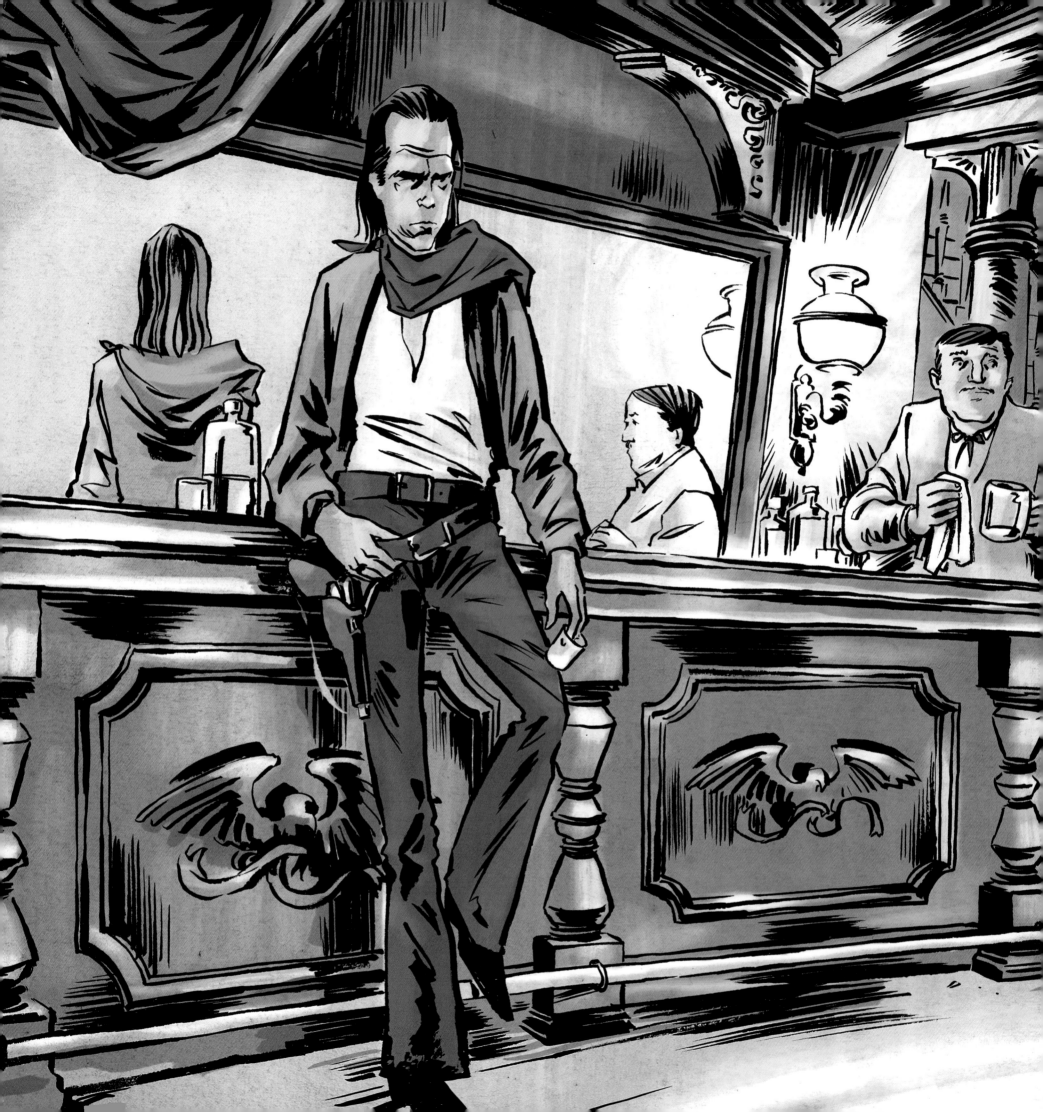

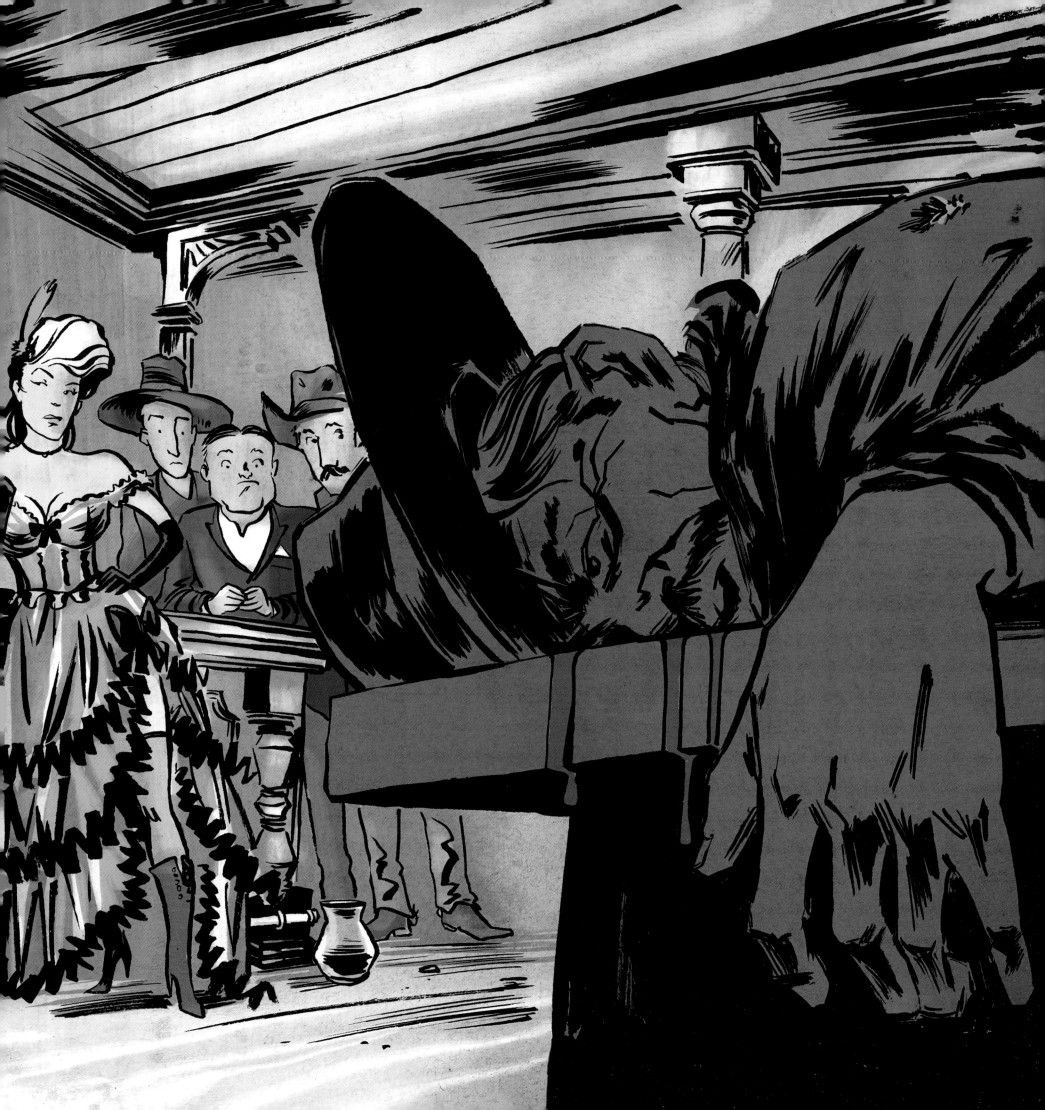

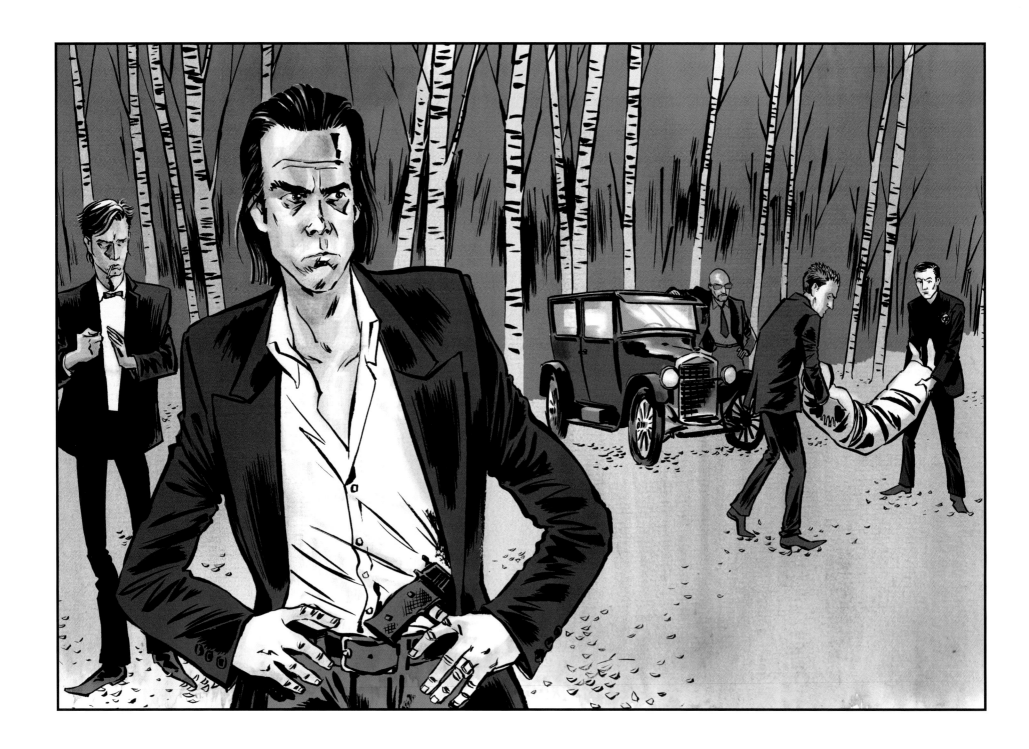

The really Bad Seeds.

◄◄ Nick Cave as the feared gunman in *O'Malley's Bar*.　　　　On the way to the electric chair in *The Mercy Seat*. ►

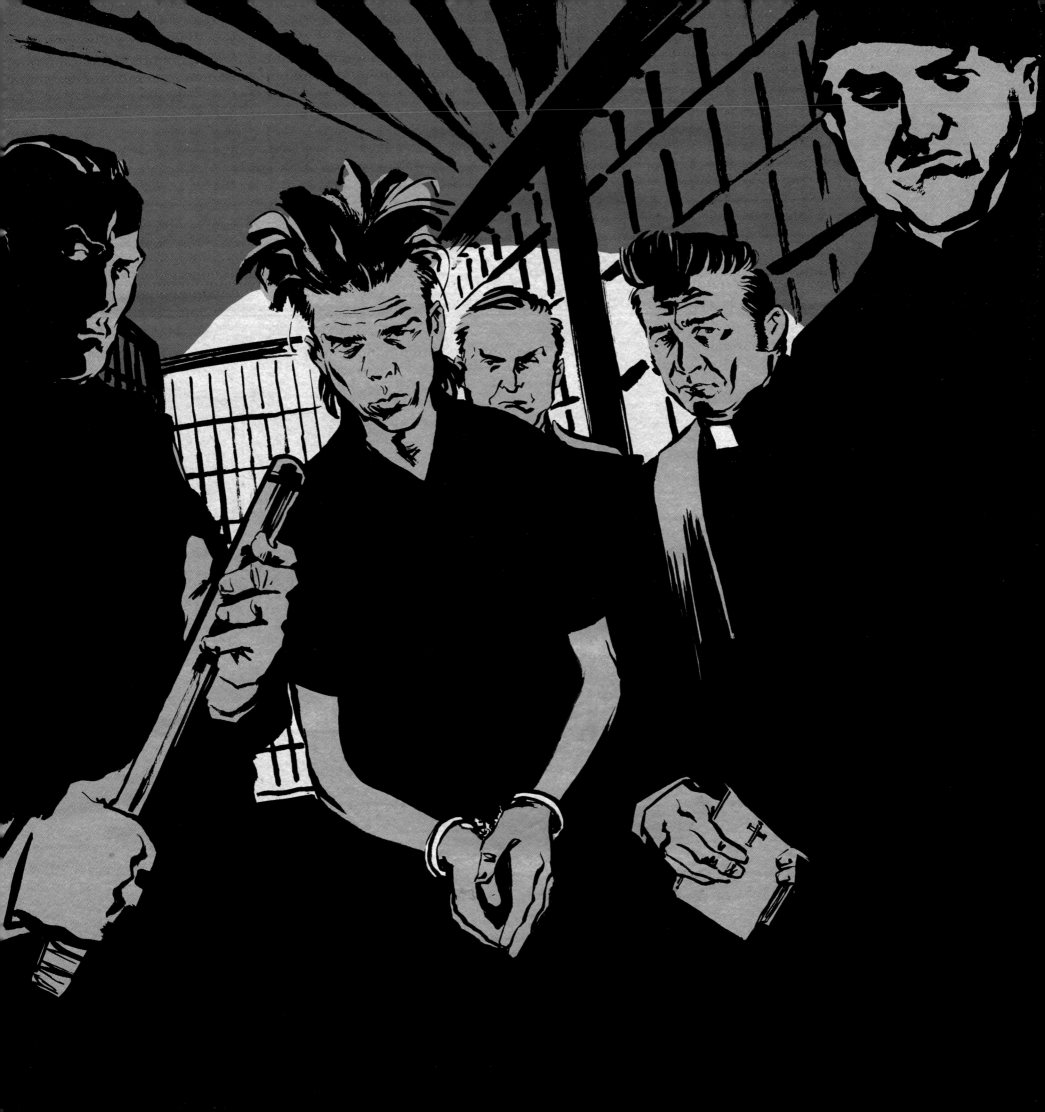

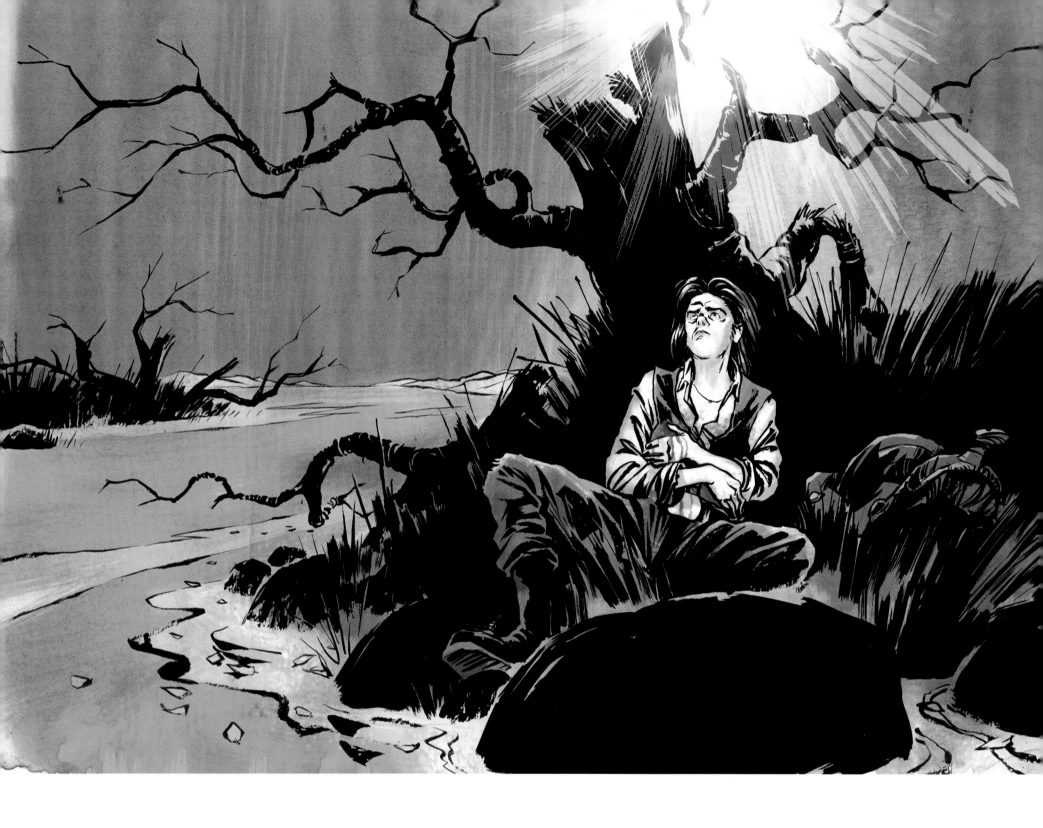

The Hammer Song. The tragic end of a young man who leaves home to find his fortune.

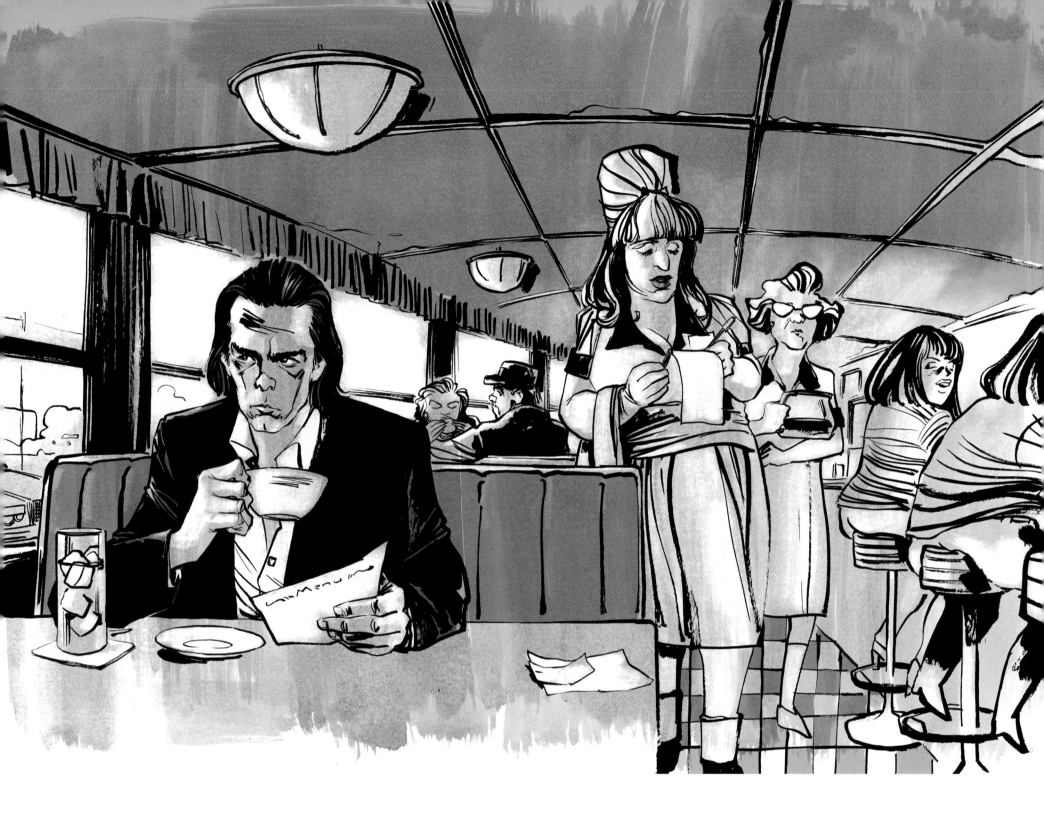

Discarded idea for the graphic novel *Mercy on Me*:
Nick Cave on an odyssey through the USA.

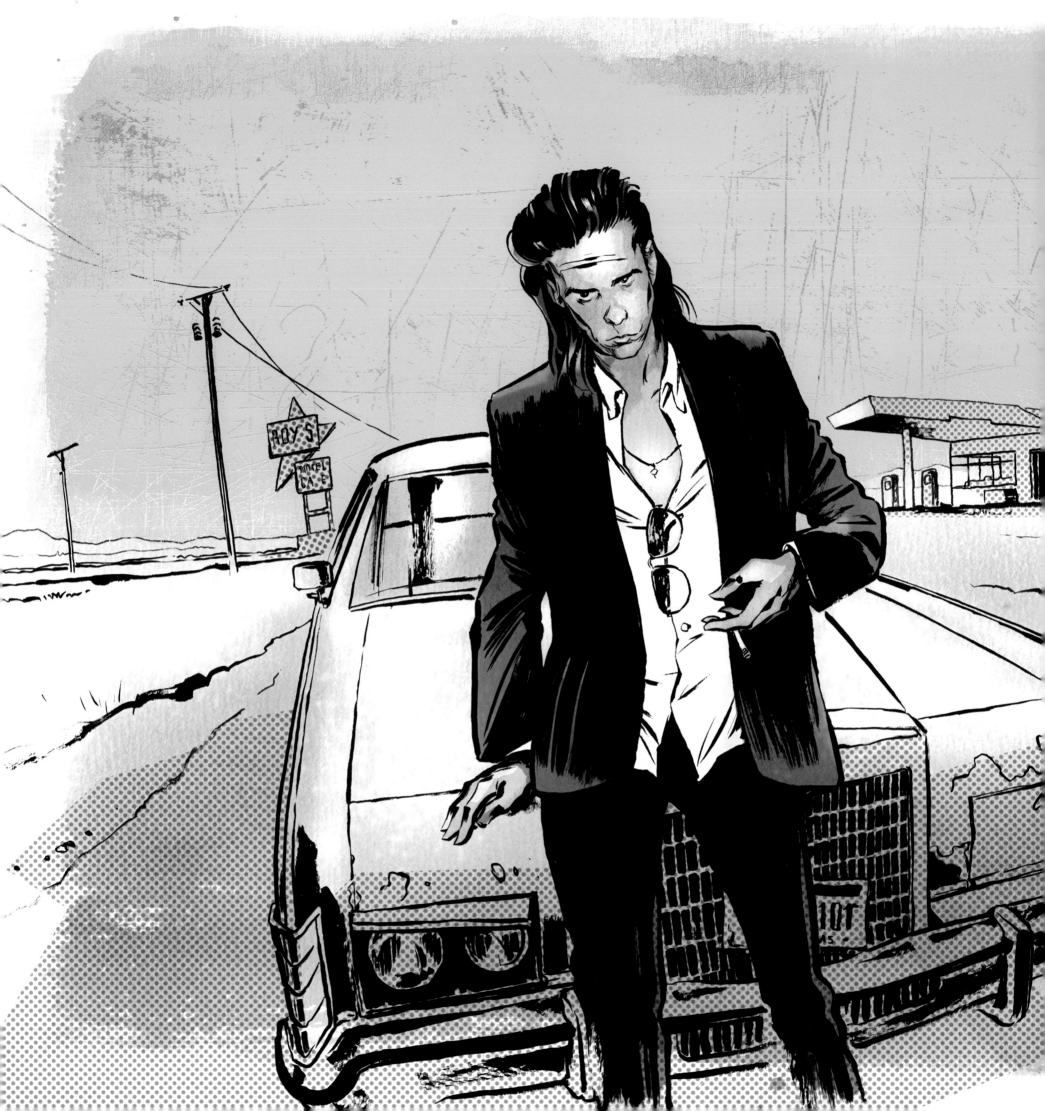

The Road to God Knows Where.
An early study for the graphic novel *Mercy on Me.*

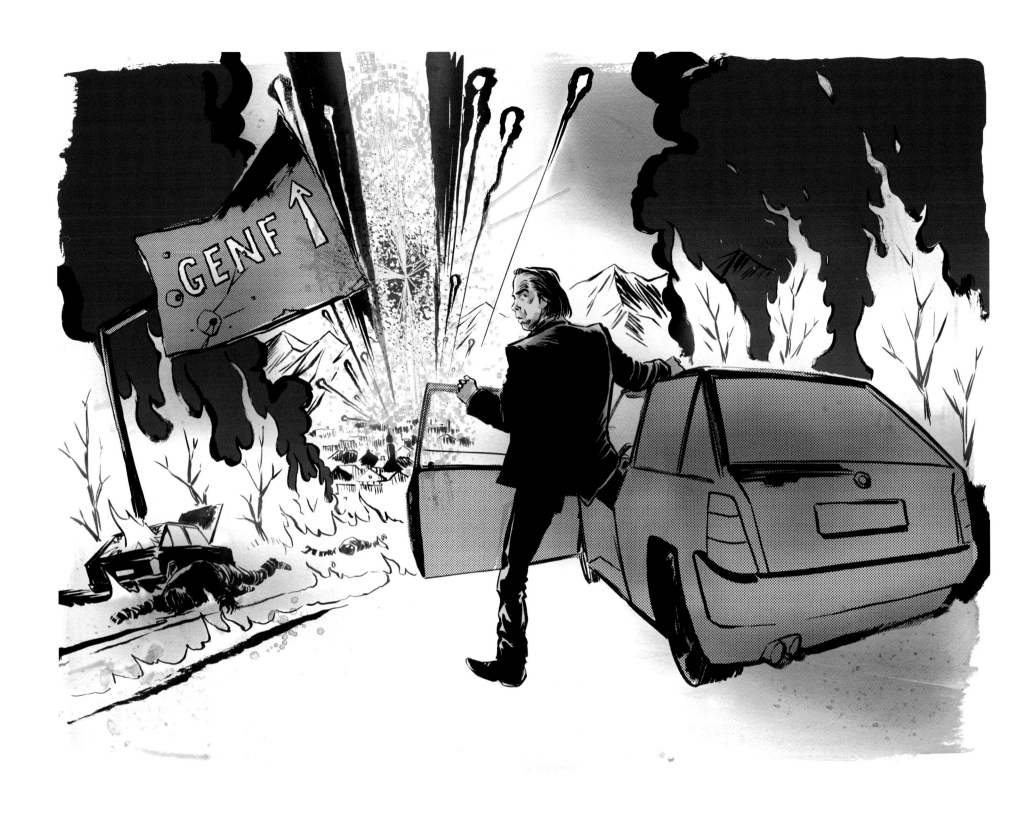

On the road to the particle accelerator in Geneva.
Illustration for *Higgs Boson Blues*.

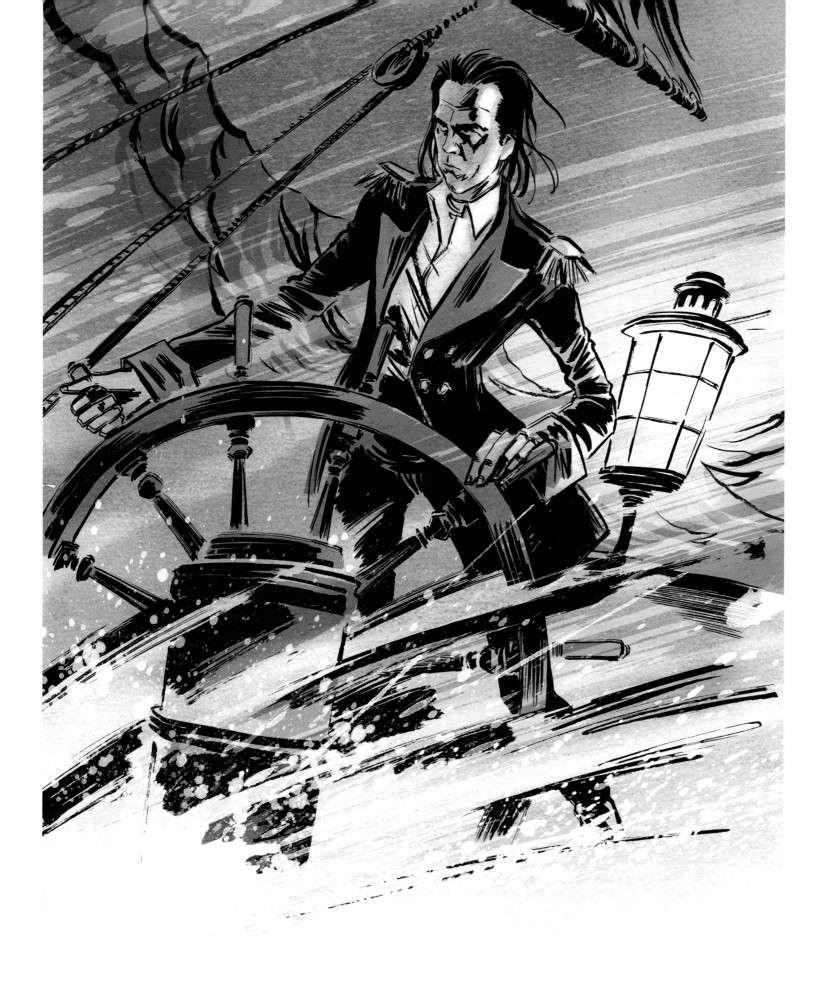

Cabin Fever. Nick Cave as the lovesick captain of a ship damned to forever sail in circles.

Opium Tea. ▶▶

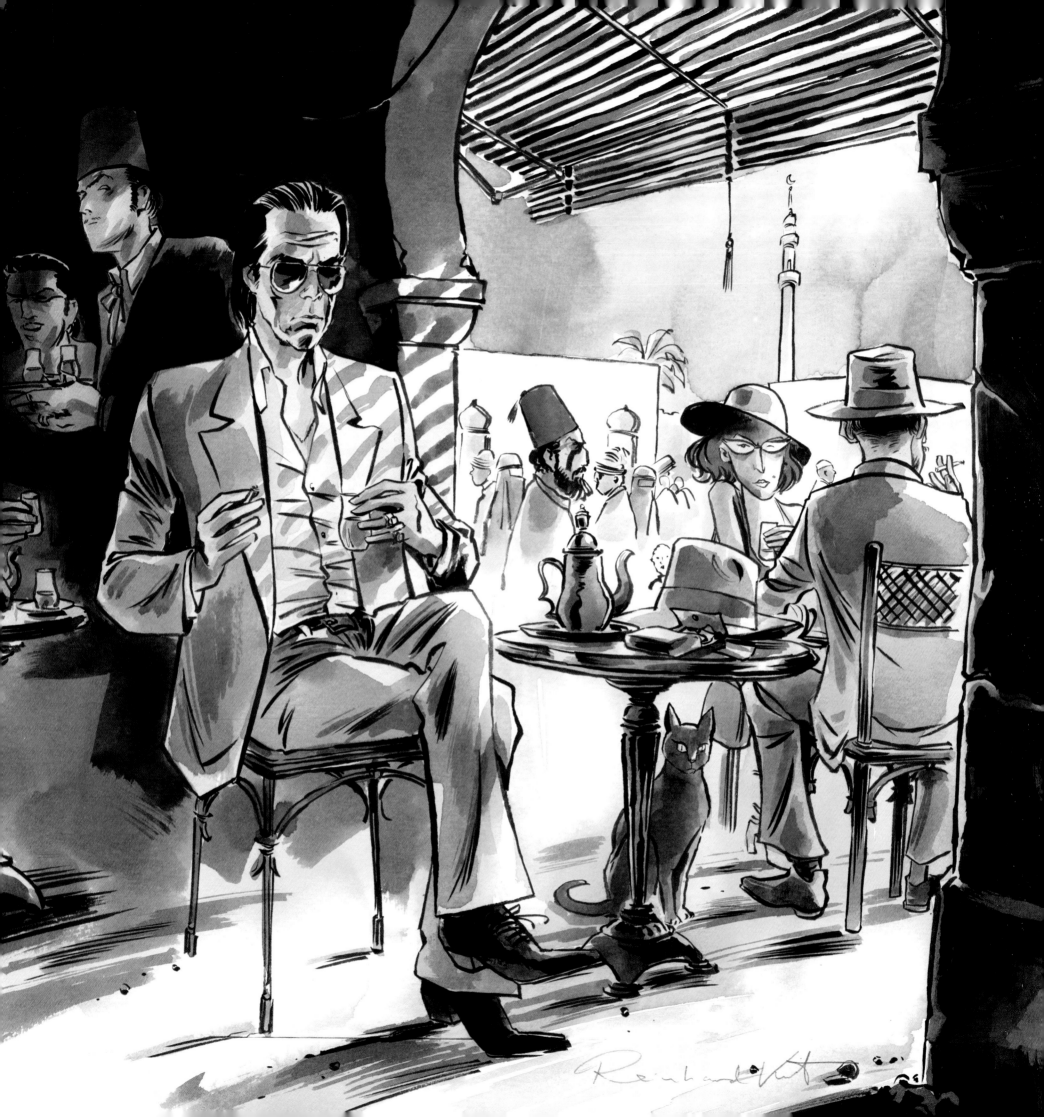

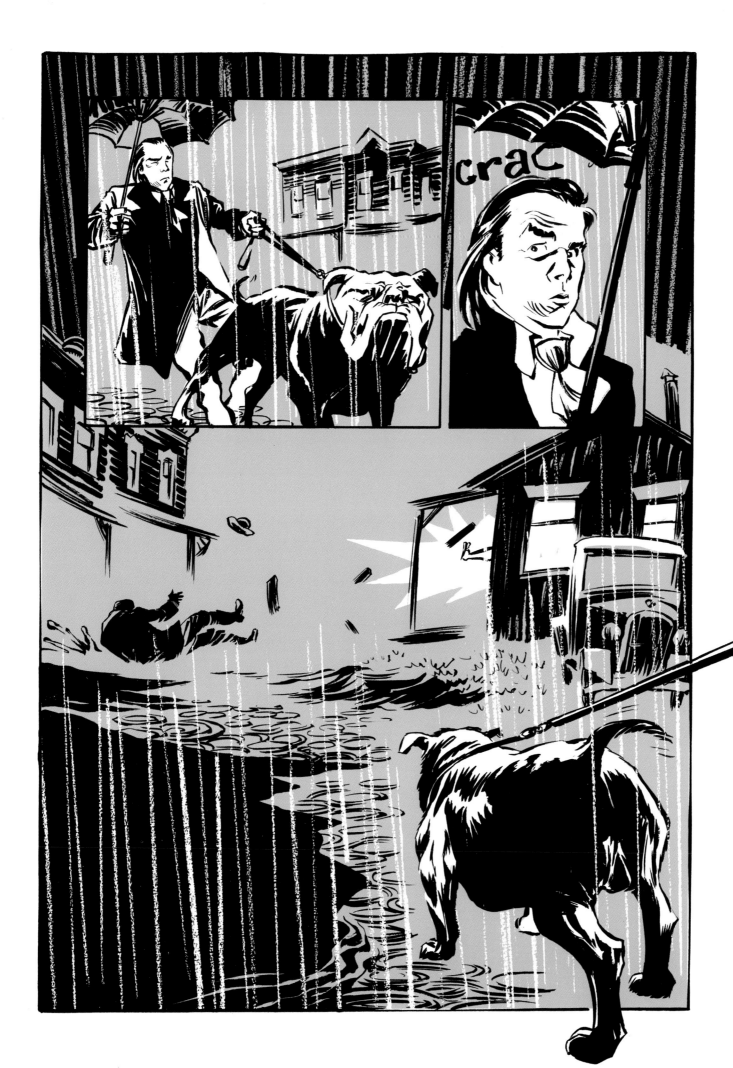

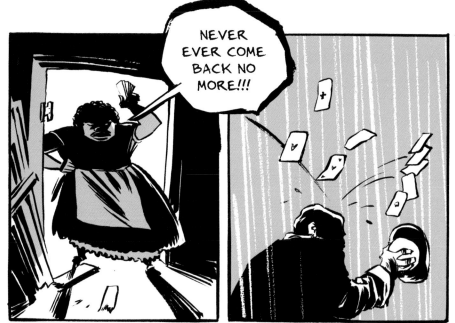

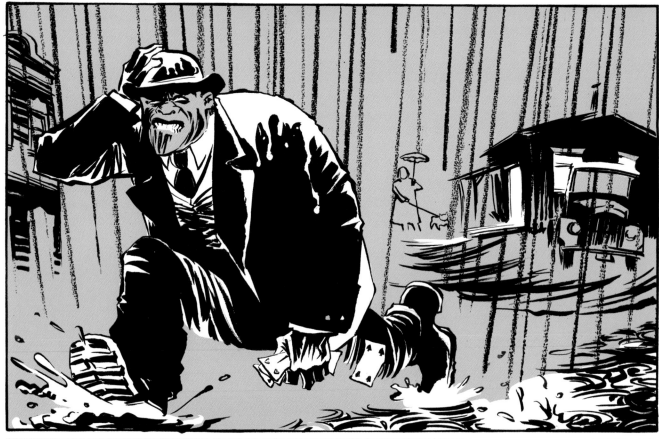

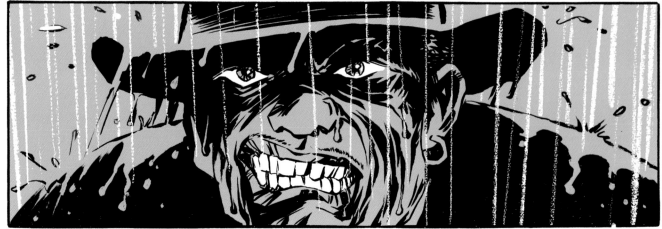

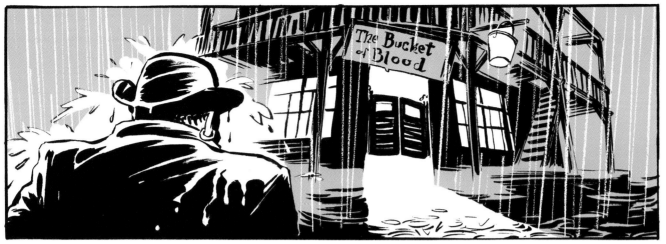

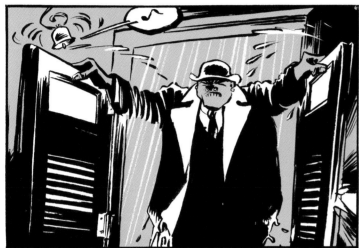

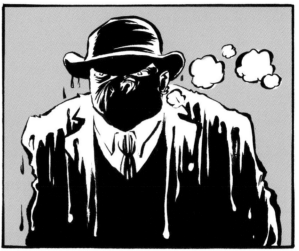

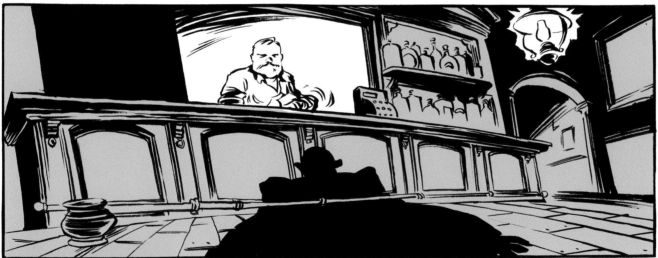

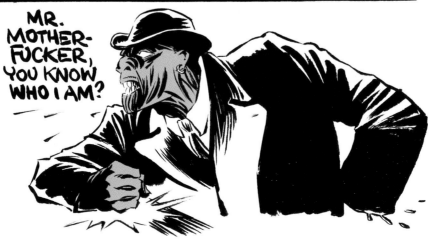

MR. MOTHER-FUCKER, YOU KNOW WHO I AM?

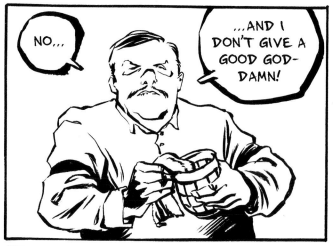

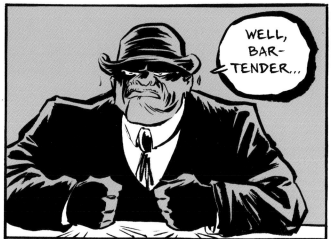

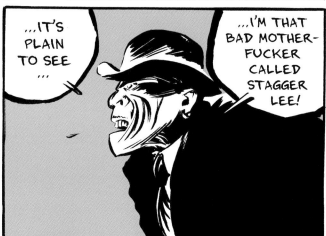

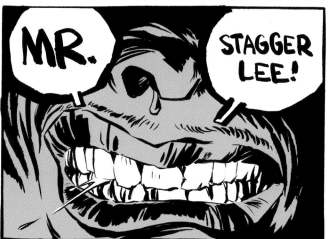

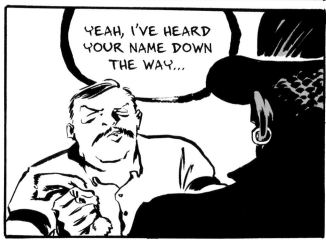

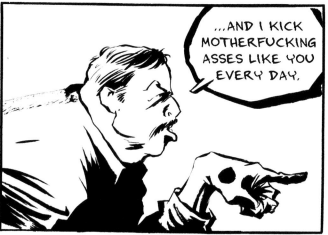

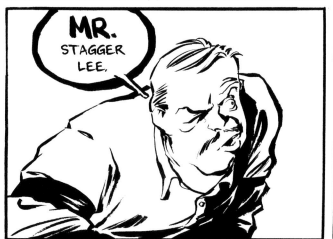

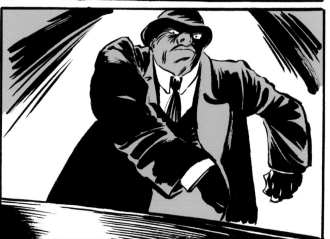

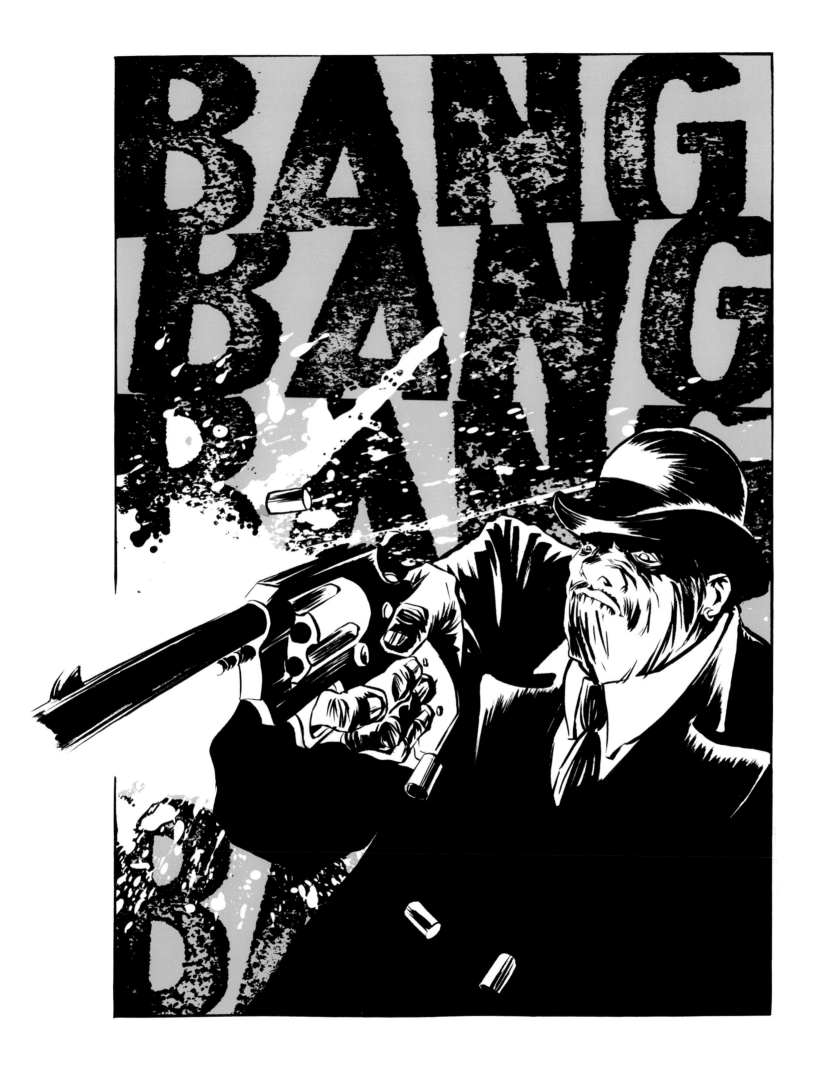

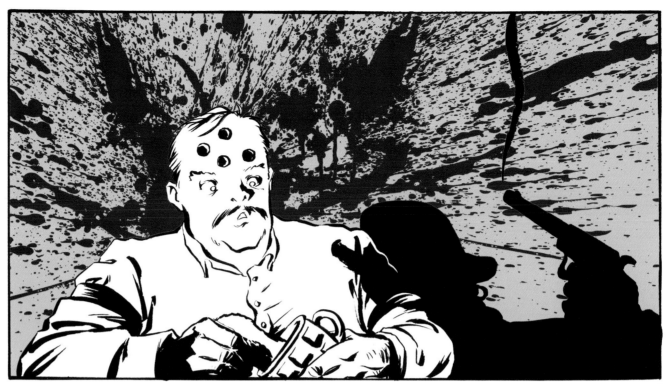

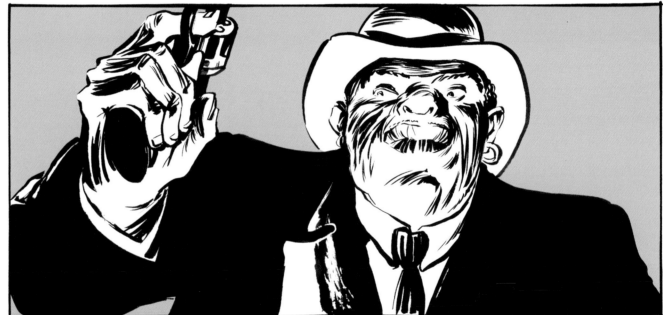

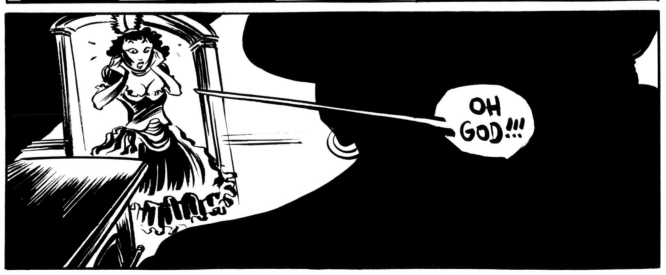

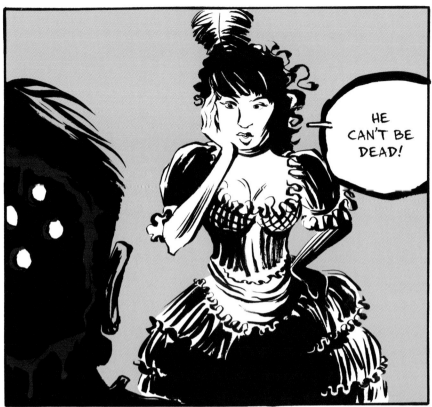
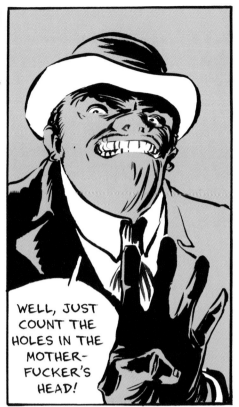
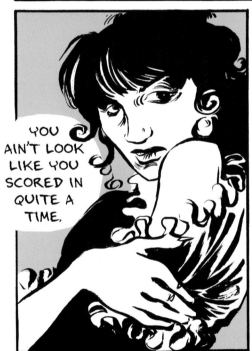
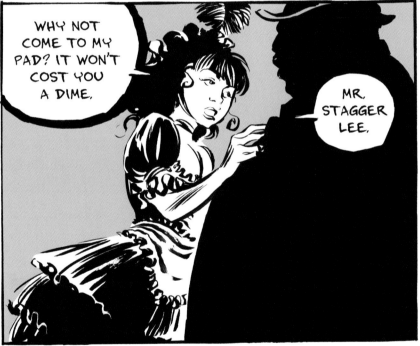
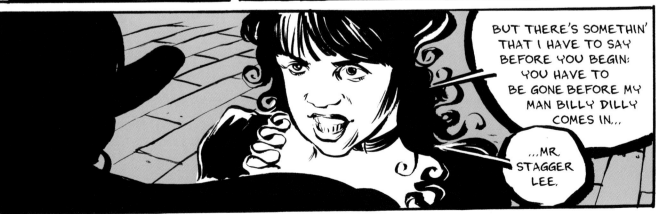

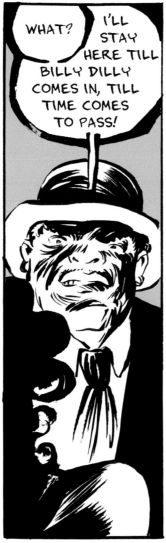

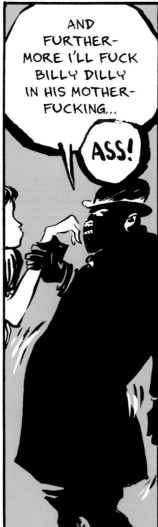

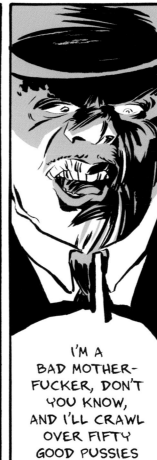

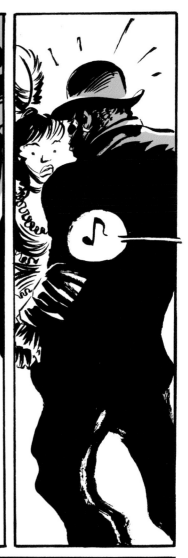

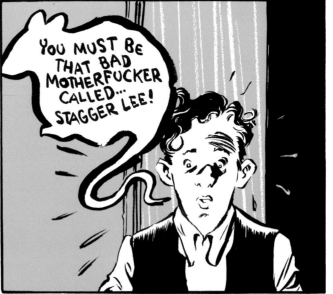

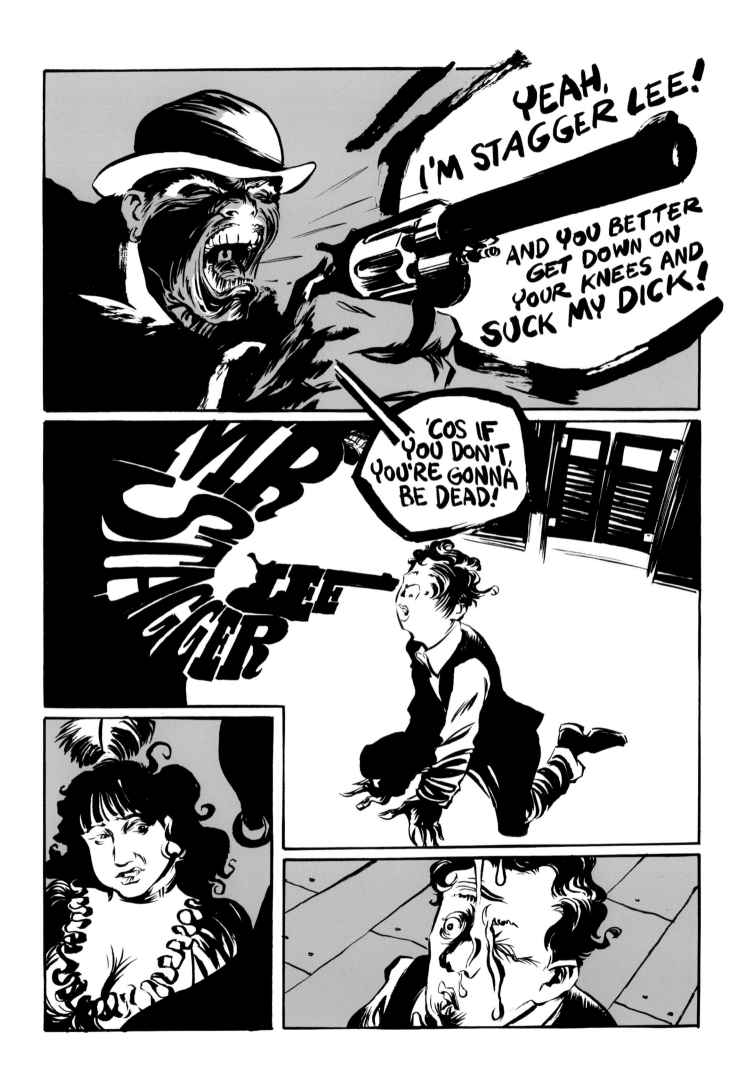

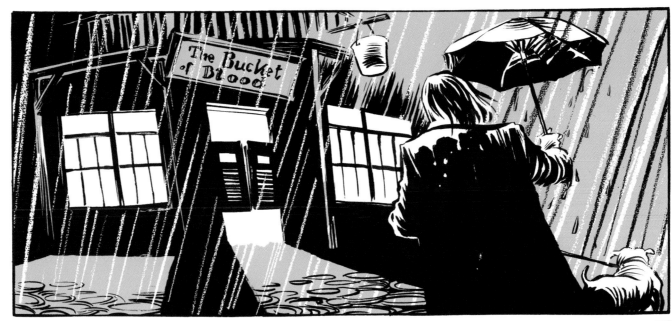

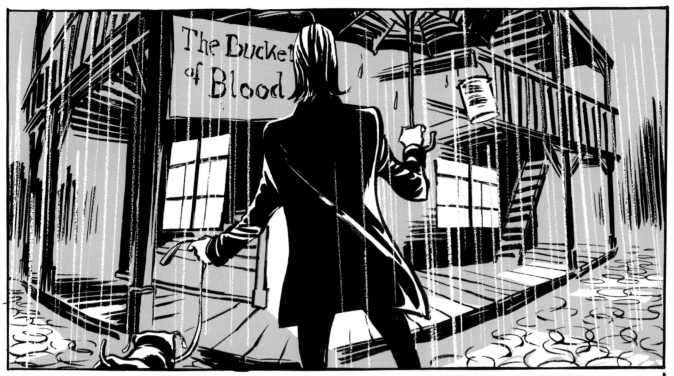

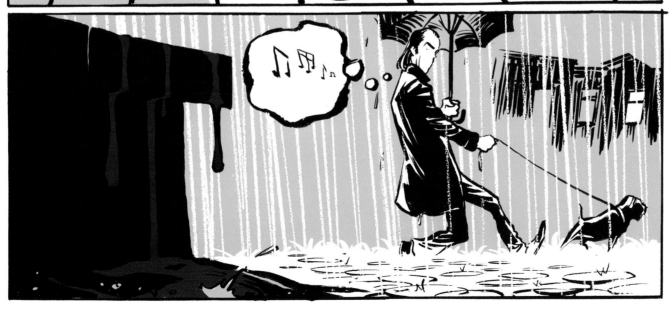

DISTANT THUNDER RUMBLE

From our vantage point to the right of the tower of speakers, we had a good view of the apocalypse before us. On stage, the Bad Seeds blazed in a murderous spectacle, barraging us with broadsides of sound. We saw Nick Cave as he entered the crowd, roaring above the heads of the audience, balancing on the barrier lattice and against the hands of the people before him. I wished I was in the front row.

I'd driven with two friends, Andreas and Janet Planet from Los Angeles, to the Greenville Festival in Brandenburg. It was the height of summer. The weather had been burning hot for days and the festival had turned out to be a pleasant surprise. The Bad Seeds were headlining and we had tickets. We also had a backstage appointment.

During the last songs of the set, dark clouds could be seen drawing in behind the stage and the oppressive heat of the day appeared intent on discharging itself in a violent storm. The show stormed towards its peak, the public bathed in sweat and greedy for more. Then the musicians left the stage and a strong wind rose, bending the trees low. Applause flared up, only to be cut short by a storm warning telling us to leave the grounds. There would be no encore.

Rachel, Nick's wonderful assistant, who I had been in e-mail contact with for weeks, was waiting at the backstage entrance. We followed her along the corridors, past musicians and roadies. A door took us back outside, where we found Nick, squatting alone on the ground. He looked at the four of us in astonishment and asked: "And which of you is Reinhard, then?" Against the backdrop of an approaching storm of biblical proportions, we chatted about the show and my thoughts on the story I had brought to him. It was completely surreal. *This is how a comic book about Nick Cave has to begin*, I thought.

The idea had been with me for years already, but I only began pursuing it once I'd had enough of dark stuff like the Holocaust (*The Boxer*) and migration (*An Olympic Dream*) and wanted to do something lighter once more. Why this sentiment led me to Nick Cave is anyone's guess. The plan solidified when, via a number of detours, I had the opportunity to present it to Nick's assistant, Rachel. She succinctly quashed my hopes with her response: "Nick sees ideas like this every week." So I was all the more surprised to find an e-mail in my inbox from Nick Cave a few weeks later. He found the idea interesting and knew my comic book on Johnny Cash, but wouldn't be able to provide much input. However, he did give me a couple of pointers, suggesting (not so surprisingly) that I cast the story as legend and mythologise his life.

I had to smoke three cigarettes to calm my nerves.

Work on the comic, which would be called *Mercy on Me*, was anything but simple. In April 2016, after having put together enough material to present something, I stood weak-kneed before the doors of AIR Studios in London, where the Bad Seeds

were in the middle of recording *Skeleton Tree*. Nick had been through a difficult time, and I wasn't sure if he still even wanted a comic book about his life. We sat drinking tea in a side room, and Nick took the time to look at everything. I was more than relieved that he liked my narrative concept and the drawings.

The artwork in *Mercy on Me* is the result of a lengthy process of stylistic discovery. At the start of the work, while I was still sounding out different narrative concepts, I had begun getting to know the persona of Nick Cave through sketches, illustrations and short comic book scenes.

More than anything, Nick Cave is one of the great storytellers among musicians. Not only does he narrate in his lyrics, but in his compositions, too, providing atmospheric accompaniment. Songs such as *Tupelo* and *The Mercy Seat* summon immediate, powerful images before my inner eye. Nick Cave creates worlds in which I can lose myself, and characters with their own lives. So if Nick is able to draw me completely into his stories, what would be more appropriate than to do the same with him?

Whether it was as the murderous lover of *Where the Wild Roses Grow*, the dark seducer in *Red Right Hand*, the lovesick captain in *Cabin Fever* or the grudge-filled farm boy in *The Good Son*, I playfully placed Nick in the roles of the protagonists of his own songs.

When I listen to *God Is In The House*, I clearly see whitewashed wooden houses with picket fences. So I let Nick play the priest of the bigoted town. Those who look closely will see that he's holding a copy of Nabokov's *Lolita* instead of a bible. The boy led astray by the femme fatale *Deanna* is also based on the young Nick Cave in my illustrated interpretation of the song of the same name. I imagine the scene of those fatal events as a sunwashed bungalow in a well-off Melbourne neighbourhood.

Likewise, in the pictures that illustrate his life, I see Nick Cave as a star playing the drunk novelist still sitting at the bar of the Risiko at daybreak with Blixa Bargeld, or the young vandal with his first band, The Birthday Party. Roles in his own film, telling the legend of a musician who became an icon.

The borders between fiction and half-truths blur. And all the better for it.

This book collects a selection of my favourite illustrations – including some of my first approaches and completely new pictures – covering Nick Cave's complete career and some of his fantastic songs.

Reinhard Kleist

Special thanks to:
Nick Cave, Rachel Willis, Michael Groenewald, Anne Haffmanns,
Max Dax, Thomas Gilke and Johnny Häusler.

1957
Nicholas "Nick" Edward Cave is born on 22 September in Warracknabeal, Australia.

1976
Nick Cave forms the band The Boys Next Door with school friends Mick Harvey (guitar, bass, keyboards and more) and Phil Calvert. Rowland S. Howard (guitar) and Tracy Pew (bass) join later.

1977
Nick Cave meets Anita Lane, who becomes his partner and muse of many years.

1978
The Boys Next Door release their debut album, *Door, Door*.

1980
The band relocates from Melbourne to London and changes its name to The Birthday Party.

1981
Prayers on Fire, the first album by The Birthday Party, receives positive reviews in the English music press as a mixture of punk and raw blues.

1983
The band moves to Berlin, where Nick Cave meets Blixa Bargeld (among others), the singer of the Berlin band Einstürzende Neubauten.

1984
The Birthday Party breaks up and Cave forms Nick Cave and the Bad Seeds with Mick Harvey (drums), Blixa Bargeld (guitar), Barry Adamson (bass, piano) and Hugo Race (guitar).

1984
The Bad Seeds' debut album, *From Her to Eternity*, is released.

ca. 1985
Nick Cave begins work on his debut novel, *And the Ass Saw the Angel*.

1987
Nick Cave's music is used in the Wim Wenders film *Der Himmel über Berlin*, which also features a brief appearance by the Bad Seeds.

1988
The Mercy Seat from the album *Tender Prey* becomes Nick Cave's signature song and achieves widespread popularity through a cover version by Johnny Cash.

1989
Nick Cave is co-writer and star of the film *Ghosts... of the Civil Dead*. His novel *And the Ass Saw the Angel* is released.

1990
Nick Cave moves to São Paulo and marries the Brazilian journalist Viviane Carneiro. Their son Luke is born a year later. The album *The Good Son* sees ballads take a more pronounced role in the oeuvre of the Bad Seeds.

1996
The album *Murder Ballads* is released. The duets with Kylie Minogue (*Where the Wild Roses Grow*) and PJ Harvey (*Henry Lee*) achieve hit status.

2005
The film *The Proposition*, written by Nick Cave, premieres.

2006
Nick Cave forms the project Grinderman with Warren Ellis (incl. guitar, mandolin), Martyn P. Casey (bass) and Jim Sclavunos (drums), releasing two albums (2007, 2010).

2009
Nick Cave's second novel, *The Death of Bunny Munro*, is released.

2013
The Bad Seeds release the album *Push The Sky Away*, featuring the songs *Higgs Boson Blues* and *Jubilee Street*.

2014
The part-documentary film *20,000 Days on Earth* is released in cinemas and is awarded the Directing Award at the Sundance Film Festival.

2016
Nick Cave and the Bad Seeds release their latest studio album to date, *Skeleton Tree*.

About the artist

Reinhard Kleist, born in 1970 in Hürth, Cologne, has worked and lived as an illustrator and comic book artist in Berlin since 1996.

He became known to a wide audience in 1994 with the book ***Lovecraft***, and made his international breakthrough in 2006 with the biographical comic book ***Johnny Cash: I See A Darkness***. Both books were awarded the renowned Max and Moritz Prize. ***Cash*** was also nominated for the Eisner Award in America. Reinhard Kleist received the German Children's Literature Award for ***The Boxer*** in 2013. In 2016, ***An Olympic Dream*** was likewise nominated for the German Children's Literature Award. In the same year, it was also awarded the Luchs-Buchpreis, the Katholischen Kinder- und Jugendbuchpreis, as well as the Gustav-Heinemann-Friedenspreis. His comic books have been translated into many languages.

In addition to his comic book works, Reinhard Kleist has illustrated numerous books and record and DVD covers, and has worked for the **Süddeutsche Zeitung Magazin**, the **FAZ** and **ARTE**. He regularly holds workshops and talks around the world.

www.reinhard-kleist.de
www.nickcave-comic.com

Song lyrics used in this book

SELF MADE HERO

First published in English in 2017
by SelfMadeHero
139–141 Pancras Road
London NW1 1UN
www.selfmadehero.com

Copyright text and illustrations © 2017
by CARLSEN Verlag GmbH, Hamburg, Germany
First published in Germany under the title
"Nick Cave & The Bad Seeds: Ein Artbook"

Written & Illustrated by: Reinhard Kleist
Translated from German to English by Michael Waaler

Publishing Director: Emma Hayley
Sales & Marketing Manager: Sam Humphrey
Editorial & Production Manager: Guillaume Rater
UK Publicist: Paul Smith
US Publicist: Maya Bradford
Designer: Txabi Jones
With thanks to: Dan Lockwood

A CIP record for this book is available from the British Library

ISBN: 978-1-910593-52-3

10 9 8 7 6 5 4 3 2 1

Printed and bound in Slovenia

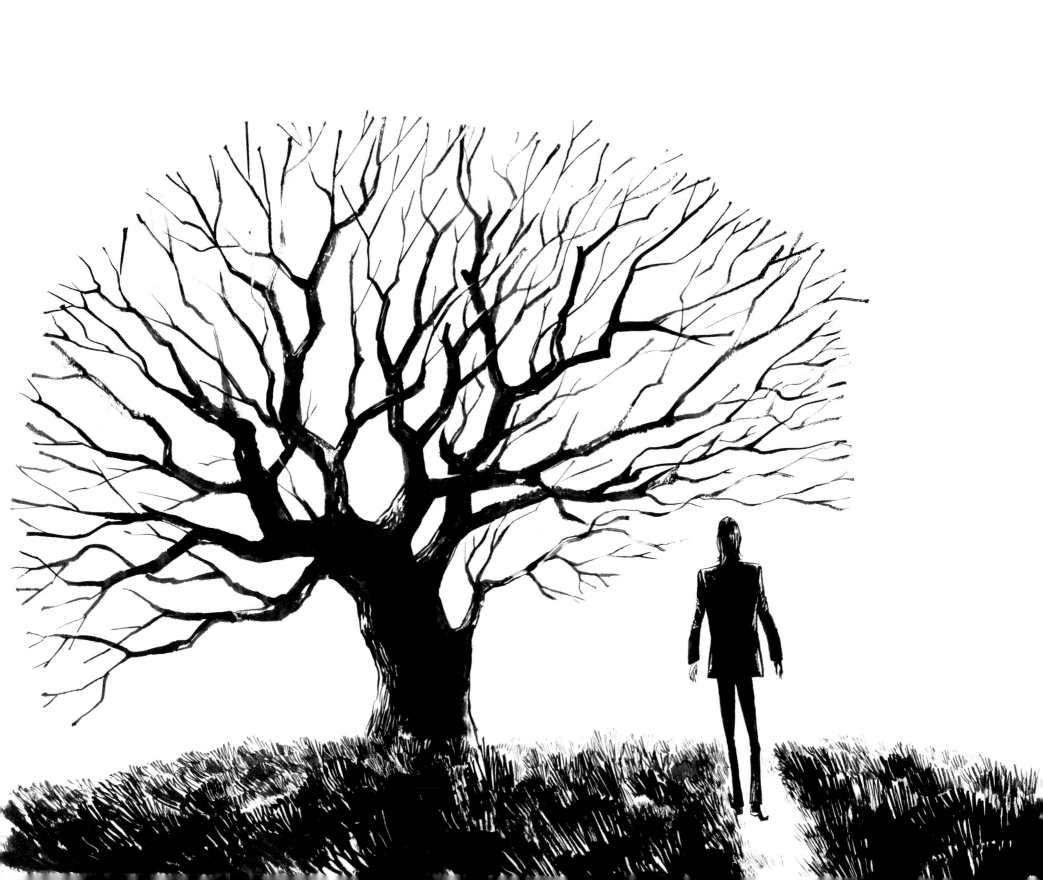